IMAG
of Ame

THE VERMONT-QUEBEC BORDER

BORDER

LIFE ON THE LINE

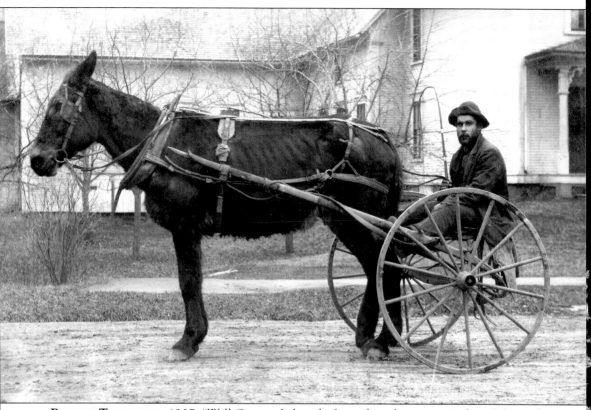

BORDER TRANSPORT, 1907. "Well George, I thought I wood send you my pittchure." So reads the message on the back of this postcard, mailed by a man named John, anxious to show off his transport to a relative in Newport. The photograph was taken near Richford or North Troy, or possibly just over the border.

On the cover: **CROSS-BORDER PATRIOTISM, DERBY LINE/ROCK ISLAND, 1920s.** Perhaps nowhere on the Vermont-Quebec border is the sense of cross-border community as strong as it is as at the Haskell Free Library and Opera House, North America's most famous line house. For more, see page 86. (Author's collection.)

IMAGES
of America

THE VERMONT-QUEBEC BORDER
BORDER

LIFE ON THE LINE

Matthew Farfan

ARCADIA
PUBLISHING

Published by Arcadia Publishing
Charleston, South Carolina

Printed in the United States of America

Library of Congress Control Number: 2008942691

For all general information contact Arcadia Publishing at:
Telephone 843-853-2070
Fax 843-853-0044
E-mail sales@arcadiapublishing.com
For customer service and orders:
Toll-Free 1-888-313-2665

Visit us on the Internet at www.arcadiapublishing.com

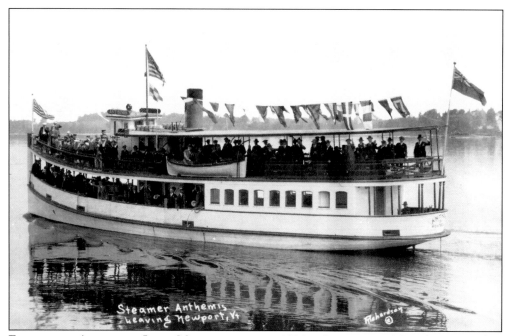

EXCURSION, ANTHEMIS, LAKE MEMPHREMAGOG, 1920S. Steamers on Memphremagog flew American and Canadian flags. In the United States, the stars and stripes flew from the bow, the red ensign from the stern. In Canadian waters, the positions were reversed. The *Anthemis* was the last of the old steamers on Memphremagog. She operated from 1909 until the 1950s. The 100-foot (30-meter) propeller-driven boat was licensed to carry up to 250 passengers in 1914. (Photograph by Harry Richardson.)

CONTENTS

ACKNOWLEDGMENTS

This book is an expression of my fondness for the people, villages, and history of the Vermont-Quebec border. The majority of photographs, postcards, and documents reproduced here are from my own personal collection, amassed over a 25-year period. The few exceptions are noted in the captions. Also noted (when known) are the names of photographers (in the case of original photographs) and publishers (for printed postcards or book illustrations).

I would like to acknowledge the people who have provided background information or interviews for this book. Particularly helpful have been Chris Anderson, Richard Baraw, Keith Beadle, George Buckland, Perry Hunt, Heather McKeown, Brian McNeal, Irene Owen, Mary Paull, Octave "Jack" St-Sauveur, Francine Tougas, Ramsey Williams, Ted Woo, and Warren Porter Woodworth. I would like to thank Josiane Caillet and Aurelie Farfan for reviewing the text and the staff of the Haskell Free Library for their assistance in procuring various publications. I would also like to thank James Farfan, Golden Rule Lodge No. 5, Ramsey Williams, and Scott Wheeler, of *Vermont's Northland Journal*, for allowing me to reproduce items from their private collections, and Steven Fick, of *Canadian Geographic*, for permitting me to reprint his map. Finally, I would like to express my gratitude to Townshippers' Foundation for supporting this project.

INTRODUCTION

"Our two communities serve as an example to the rest of the world of how two municipalities in two different countries can get along, and, in a larger sense, how countries can live together for their mutual benefit. We are proud of the spirit that exists here on the border, and we do not accept to be penalized for a simple accident of geography which, for us, is all that the border really is."

—Derby Line–Stanstead Joint Municipal Committee on Border Issues, 2007

For much of its history, the line separating Vermont from Quebec has served as a backdrop to the daily lives of people living within its shadow. Although this 90-mile (145-kilometer) section of the Canada-U.S. boundary is essentially an arbitrary line across the countryside, it has affected settlement, trade, and travel for over 200 years.

The Vermont-Quebec border was first established by British royal proclamation in 1763, set out in the Quebec Act of 1774, and finally enshrined in the Paris Peace Treaty of 1783. In 1763, both the American and the Canadian colonies were dependencies of Great Britain. Canada (New France) had just been ceded by France to Great Britain, along with French claims to what is now Vermont.

The northern border of the future state of Vermont was established—on paper at least—at 45 degrees north latitude. John Collins and Thomas Valentine were dispatched between 1771 and 1774 to survey the line from Lake Champlain to the Connecticut River. As it happened, they made serious errors in their calculations. Perhaps their primitive instruments and mapping techniques were to blame, or the difficult conditions they experienced in the bush. Whatever the case, according to local folklore, they simply drank too much whiskey while on the job, and the "parallel" they surveyed was actually a crooked line that zigzagged well to the north of the 45th parallel.

For years, there was uncertainty about the location of the border. Before 1800, few settlers inhabited the region, so the issue hardly arose. However, as more settlers arrived, problems began to occur. Some contended the border was where the surveyors had placed it; others said that it was farther south, where the treaties had intended it. Some built homes in what they thought was one country, only to learn later that it was another. At Lake Champlain, the Americans built a fort (nicknamed "Fort Blunder") nearly a mile north of the 45th.

In 1842, the United States and Great Britain signed the Webster-Ashburton Treaty, which essentially left the border where the surveyors had placed it. To this day, many people still believe that the border separating Quebec from Vermont is the 45th parallel.

At the time of the Collins-Valentine survey, Vermont was actually claimed by both New Hampshire and New York. However, in 1777, the Republic of New Connecticut (quickly renamed Vermont) was declared. The entity governed itself as an independent country until it became the 14th state of the United States in 1791.

Settlement in Vermont was at first concentrated in the south, with Lake Champlain and the Connecticut River on opposite sides of Vermont acting as corridors of northward migration. By the late 1700s, settlers began to penetrate the northern and north-central areas, moving closer to the Canadian border.

North of the border, the vast wilderness between New England and the old French settlements along the St. Lawrence and Richelieu Rivers was deliberately kept free of settlement by the British in Quebec. The region served as a buffer zone between what was until recently French territory and the new republic to the south. By 1792, however, Britain's position had changed. It was now felt that this "wasteland" would make a suitable home for British immigrants and others loyal to the crown. The region was surveyed and divided into townships. Grants of land in what would soon be known as the Eastern Townships were made to loyalists fleeing persecution in the United States and to others favored by the crown.

Beginning in the 1790s, a growing number of settlers made their way into the Eastern Townships from Vermont and other parts of New England. Interrupted only by the War of 1812, settlement continued until the 1830s. Some of these pioneers were loyalists but, contrary to an enduring myth that the Eastern Townships were populated largely by this group, the majority of these people were simply looking for good, cheap farmland and the opportunity to start a new life. As historian Cyrus Thomas once wrote, they were anything but "martyrs to their political principles, [and] cared as little for royalty as they did for republicanism."

As settlement moved into northern Vermont and Canada, towns in Grand Isle, Franklin, Orleans, and Essex Counties, Vermont, found themselves on the edge of a frontier that was shifting to the north. The border posed little obstacle to settlement.

For several decades, the culture north of the border was very much an extension of that to the south. Members of extended families lived on opposite sides of the line. Trade functioned almost as though there were no border at all. People traveled freely back and forth. Settlements in the Eastern Townships were served by preachers from Vermont. Popular attitudes and traditions were almost indistinguishable. Settlers in the townships, like those in Vermont, possessed a strong democratic streak and demanded (and eventually received) elected representation for their frontier communities. They were also patriotic, and the Fourth of July was as celebrated north of the line as it was in the United States.

For a time, the British looked with suspicion upon the presence of so many Americans in the Eastern Townships. In the words of one official, British and French Canadian settlement was needed "to give a proper bias and tone to the political feelings of the people."

The first primitive roads in the Eastern Townships were continuations of roads in the United States. Not surprisingly, communication was easier between the townships and New England than it was between the townships and Montreal. This situation persisted for some time, with the occasional interruption, such as the War of 1812, which was seen by many locals as a nuisance that hindered the friendly relations between settlers living on opposite sides of the boundary.

As settlers crossed from the Unites States into Canada, ties of kinship, friendship, religion, community, and commerce united families and villages in both countries. For decades, the Eastern Townships were populated largely by Americans. Ties between the two countries remained strong. Today thousands in the townships trace their ancestry back to New England.

In the mid-19th century, French Canadians began migrating to the Eastern Townships. Many crossed into the United States. From the 1840s to about the 1930s (later in some areas), nearly a million French Canadians migrated to New England. Thousands went to work for logging companies or took jobs in mill towns or with the railroads. Others took up farming in northern Vermont. To this day, many of their descendants still speak French at home. With about 142,000 people (or 23.3 percent of the state's population) claiming French or French Canadian

background, Vermont is home to one of the largest French-speaking populations in the United States. This is especially true of the so-called Northeast Kingdom.

Not surprisingly, numerous people along the border hold dual citizenship. For many Canadians, the closest hospitals at one time were in the United States, and this was where their children were born. Dual citizenship has allowed these people a greater freedom to live and work in the country of their choice. It has also tended to blur the differences between communities on opposite sides of the line. Yet, with the adoption of Medicare across Canada in the 1960s and early 1970s, and skyrocketing health care costs south of the border, having a baby in the United States was no longer as practical for Canadians as it once was.

From an early date, smuggling was a fact of life on the border. The frontier was porous, and little could be done to halt the flow of goods north and south. Customs were inexistent at worse, ineffective at best. The first customshouse in the Eastern Townships was opened in 1821. It was a mile and a half from the border! The United States opened offices in Vermont as well. Yet despite these efforts, there were countless unwatched border crossings and smuggling was rampant.

James Thompson, a customs collector in Stanstead, Quebec, wrote in 1851 that people in the village were "shrewd and lawless and ever willing to aid smugglers." James Ford, a colleague, wrote of the appalling treatment that officers could receive if they dared to seize contraband. "I was set upon," he wrote, "by six or eight men having their faces blackened and otherwise dressed to avoid detection. They chased me and, throwing upon me like so many wolves, they tied my legs with rope, when they immediately commenced cutting my hair with curses and execrations and said they would tar and feather [me]. I had once an opportunity to hallo for help [but they] gave me cause to rue it for they dug into my breast and stomach in a most furious manner, clapping their sooted hands on my mouth till they nearly suffocated me."

Needless to say, law enforcement today is more sophisticated than it once was. Officers are more numerous, better paid, better trained, and better equipped. There are also many more ports of entry than there once were. Most of the unguarded back roads are closed, and cutting-edge technology assists agents in apprehending smugglers or those crossing the border illegally.

Or at least it is supposed to do so. Newport resident Richard Baraw, a U.S. Customs inspector from 1970 to 1997, is not so sure. Based in Derby Line (usually Interstate 91), with stints in North Troy, Beebe, and Canaan, Baraw was at customs when the "age of the computer" arrived. Computers, he says, "required inspectors to use their brains a lot less." Before that, "we relied on our sixth sense. But now, computers could initiate searches—of cargo trucks, for example— based on previous problems with the company. But these searches rarely turned up anything. In my last ten years at Customs, all of my big seizures were because of my sixth sense—not because a computer told me what to do." If Baraw is correct, there is much more to policing the border than technology, and ample room left for human judgment.

Another factor that has changed things at the border is the 1988 Canada-U.S. Free Trade Agreement. This agreement eliminated many of the duties payable at customs. Yet, although the incentive for smuggling has been reduced, lower retail prices and sales taxes on many items sold in the United States still act as powerful inducements for Canadian consumers. Some declare their purchases when they return to Canada, paying the appropriate taxes at the customs; others do things the old-fashioned way—they smuggle. So, while improvements have made the border more secure and reduced the flow of contraband, smuggling has not been eradicated. Indeed, as long as borders separate jurisdictions with different laws and different levels of taxation, it will no doubt be a fact of life.

Not surprisingly, tales of smuggling hold a prominent place in local folklore. Almost every border resident has at least one good smuggling story to tell. Many of these tales involve the running of contraband liquor or cigarettes. In more recent years, talk has revolved around the smuggling of narcotics or illegal aliens.

Residents on opposite sides of the Vermont-Quebec line have long taken the border in their stride. Until recently, crossing in one direction or another was as easy as going to the corner store. For many locals, this was literally the case. They purchased groceries, gasoline for their

cars, and browsed for products of all kinds. They crossed to go to the bank, the post office, or local restaurants. Many crossed to visit friends or relatives. Customs officers greeted people they recognized with a wave of the hand— often with no questions asked.

Since the terrorist attacks of September 11, 2001, however, the border has become the focus of intense scrutiny by the American government. The new Department of Homeland Security is reevaluating traffic across the Canada-U.S. border, and security has been tightened by both countries. Not surprisingly, towns on both sides of the border have been keenly interested in this process. Most of them do not wish to endanger the friendly relations—and profitable trade— they enjoy with their neighbors.

A number of border towns share services with communities across the line. Enosburg Falls, Vermont, for example, has mutual-aid fire agreements with Sutton and Philipsburg, Quebec, allowing departments from these towns to aid each other in time of need. On the opposite side of the state, the Beecher Falls Fire Department, which bills itself as "Interstate and International," services (under contract) a number of towns in Quebec, including East Hereford and Saint-Venant-de-Paquette. Derby Line, Vermont, is particularly known for its international character. The village shares a water system, sewers, church services, sports facilities, and a library and opera house with Stanstead, Quebec. Several homes actually straddle the boundary, and organizations, such as the Rotary Club of the Boundary, include members from both countries.

Cooperation and a sense of community are cherished by residents of villages like these. These people see the border as a minor obstacle, a necessary inconvenience. Their profoundest wish is that it not become such a nuisance that it alienates communities that have coexisted peacefully on opposite sides of the line for over two centuries.

This book is intended as a visual record of life in the villages, towns, and countryside in a unique and special part of the world. A book of this nature is timely. In recent years, issues relating to the border have been thrust to the forefront as never before. This is due not only to growing security concerns but to an increasing scrutiny in the media of border issues and of how heightened security is impacting life in communities all along the border.

It is hoped that this book will serve as a reminder of the role the border has played in the history and the everyday lives of people living along its length—in Vermont and Quebec—and of how it will no doubt continue to play a part in shaping these communities.

One

BORDER COMMUNITIES

In a 1977 editorial, Lloyd Bliss of the *Stanstead Journal* wrote:

> From Ottawa or Washington this international community is something that can not possibly exist officially. But it does still exist at the community and personal level. Our fire departments . . . stand ready at all times to assist one another. Our churches and service clubs see no border when someone is in need. We all have friends and relatives on both sides of the border and few of us ever think of the other as a Vermonter or a Quebecer. This is as it should be, and how it can be if we can keep the bureaucrats out of our lives.

Bliss, whose weekly newspaper included subscribers in both Quebec and Vermont, expressed this opinion over 30 years ago. It is a sentiment that is still echoed by many along the border, including residents and lawmakers, many of whom feel, quite strongly, that while border security should be a priority, and that law enforcement agencies do have legitimate concerns, security measures should not be so intrusive that they detract from the quality of life of local residents and businesses.

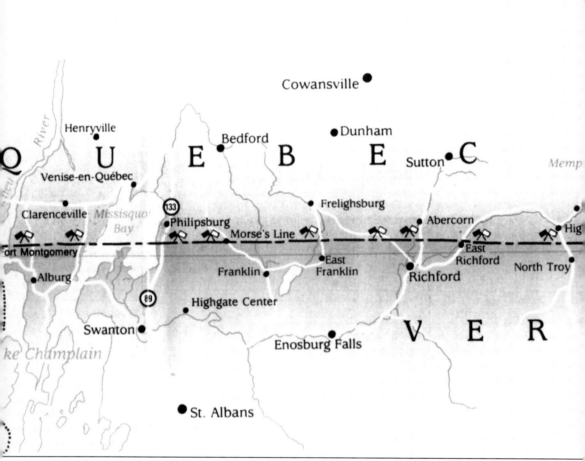

THE VERMONT-QUEBEC BORDER. According to the International Boundary Commission, the border between the United States and Canada is "so long, and in many places, so tortuous, that it took more than a century to complete its delimitation and demarcation." The Vermont-Quebec section was meant to correspond to the 45th parallel. Things never worked out that way, and the Vermont-Quebec border in its entirety falls to the north of the 45th—in some cases over a

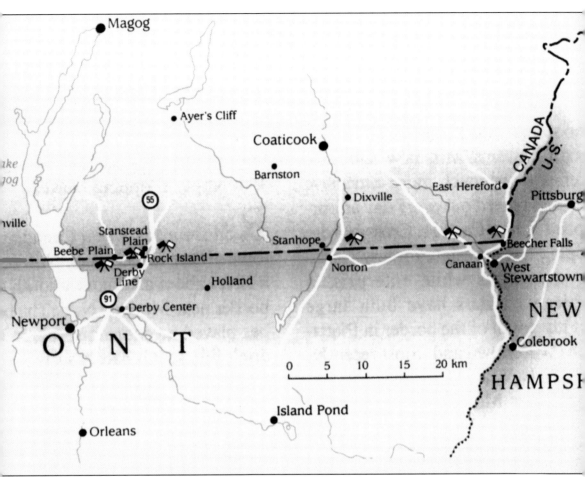

mile north of it. This map shows some of the communities along its length, from Beecher Falls in the east to Alburgh in the west. Ports of entry are also indicated, as is the zigzag laid out by the surveyors, a line that has served as the undisputed boundary between the two countries since 1842. (Map courtesy of Steven Fick and *Canadian Geographic*.)

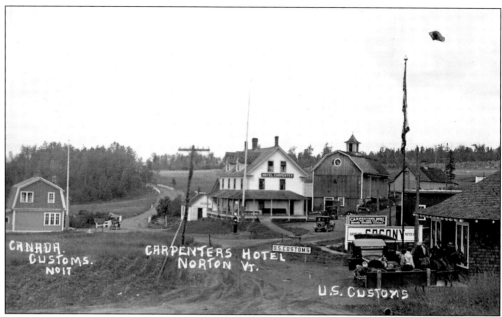

NORTON, VERMONT/STANHOPE, QUEBEC, 1920S. Norton is a hamlet on the Canada-U.S. border, adjacent to Stanhope, Quebec. The two communities were so close-knit that the local general store was built directly on the border and served customers from both countries. Not far away were the U.S. and Canada Customs, above. A sign read, "Carpenter's Hotel—Fill Your Car Before Entering Canada."

JAY, 1905. Jay is situated on the Canadian border on the rugged east side of the Green Mountains, in Orleans County. Established in 1792, the town is named after John Jay, one of the founding fathers of the United States. Jay is best known for Jay Peak, one of Vermont's highest mountains and a major ski resort catering to skiers from both sides of the border.

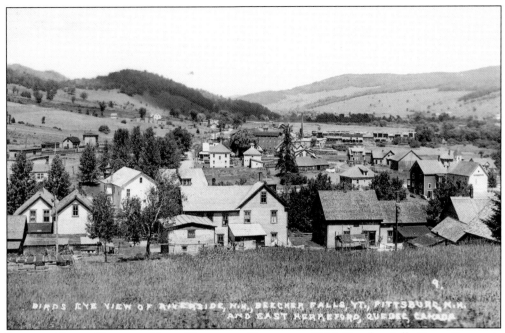

BEECHER FALLS, VERMONT/EAST HEREFORD, QUEBEC, C. 1915. Beecher Falls, Essex County, is situated at the northeastern extremity of Vermont, in a small panhandle between the Canadian border to the north and the Connecticut River and Stewartstown, New Hampshire, to the south. This view was taken from the New Hampshire side of the Connecticut River.

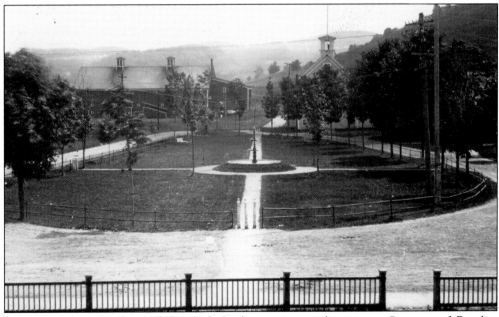

CANAAN, 1909. Residents of Hereford, Quebec, maintain close ties to Canaan and Beecher Falls, Vermont, and West Stewartstown, New Hampshire. Irene Owen, for example, gave birth to all her children at the hospital in West Stewartstown. "It was easy," she says. "Instead of driving all the way to Coaticook to have your baby, you just filled out a form and crossed the border. Of course, you had to declare your baby on the way back!"

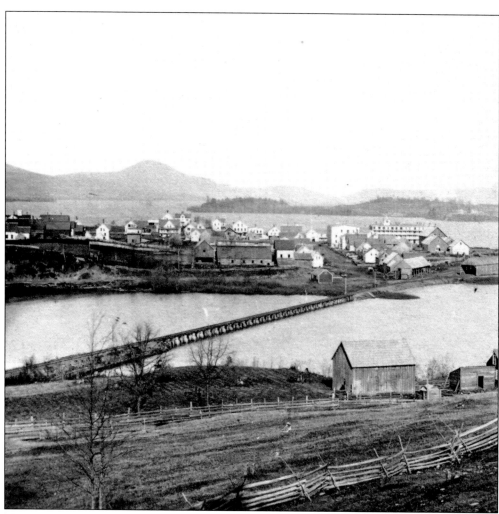

NEWPORT, 1860S. Billed as a "gateway between New England and Canada," Newport lies at the south end of Memphremagog, an international lake that stretches north into Canada. About 27 miles (44 kilometers) long, Memphremagog is fed by the Barton, Black, and Clyde Rivers, all in or near Newport, and drains via the Magog River, at the north end. Newport occupies a strategic point at the lake's narrows. Indeed, native peoples once camped here, as they did elsewhere around Lake Memphremagog. Settlement in the township of Newport (chartered as Duncansborough in 1781) was slow. By the mid-1800s, however, the population was growing. People traveled from Derby (and Canada) to points west and south, crossing Memphremagog by means of a primitive ferry near what is now the city's downtown. In 1832, a log bridge was built, but it collapsed in 1837. Its replacement fared better and contributed to the growth of the community. Known for a time as Lake Bridge, by 1864, Newport was a large enough village to separate from the township. (Photograph by A. F. Styles.)

BRUNELLE HOUSE, NEWPORT, C. 1880. What is today one of the main towns in the Northeast Kingdom began as a log cabin in the wilderness. Fisherman Isaac Brunelle, who built Newport's first home, was described by William Bullock (*Beautiful Waters*) as "a French Canadian and a very clever, honest man, ever ready to do his neighbor a kindness." Brunelle died in 1885, aged 94 years. He had 22 children by three wives. (Photograph by D. A. Clifford.)

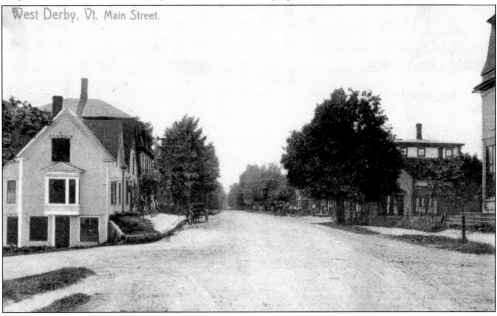

WEST DERBY, C. 1906. West Derby, opposite Newport, was a mill village from an early date. Established along the Clyde River, as it flowed into Lake Memphremagog, West Derby was incorporated in 1894, but its independent existence ceased when it amalgamated with Newport Village to form the city of Newport in 1917. This image was published by Bigelow's Pharmacy in Newport, Vermont.

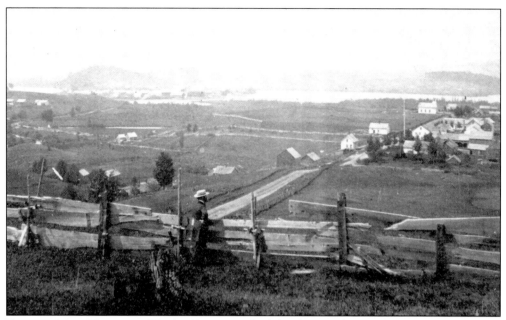

DERBY, 1860S. The town of Derby, Vermont, which borders Quebec, includes two incorporated villages—Derby Center and Derby Line, both chartered in 1891. West Derby, above, was absorbed by the city of Newport, Vermont, in 1917. The agricultural nature of the district is clear in this early photograph, although in recent times, parts of town have become highly urbanized. (Photograph by Whitney and Paradise.)

DERBY CENTER, 1870S. Derby's first permanent settler (1794) was Timothy Hinman. A Revolutionary War veteran, Hinman surveyed roads and helped to open up the border area to settlement. He operated a tavern and store, was active in politics, and served as a judge on the Orleans County Court. This view overlooks Derby Pond and the cemetery near the old Hinman homestead. (Photograph by Farmer Taylor.)

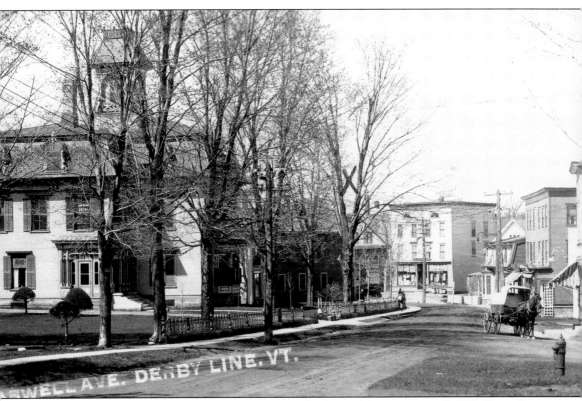

DERBY LINE, C. 1915. Derby Line was pioneered by Samuel Pomroy around 1798. Samuel's brother, Selah, settled just north of the border. Samuel cleared about five acres in what would later become the village center. Today Derby Line is one of New England's largest ports of entry, with customs and immigration facilities in both the village and on Interstate 91. The village is also a curiosity in that a number of its buildings, including the houses on the right side of this photograph (Caswell Avenue), are bisected by the Canada-U.S. border. Derby Line's Canadian counterpart is Rock Island (now a part of Stanstead). The boundary that separates the two towns cuts through homes, a factory (Butterfield's), and the unique Haskell Free Library and Opera House. The two communities even share a water system—managed (appropriately) by the International Water Company, which is made up of directors from both communities.

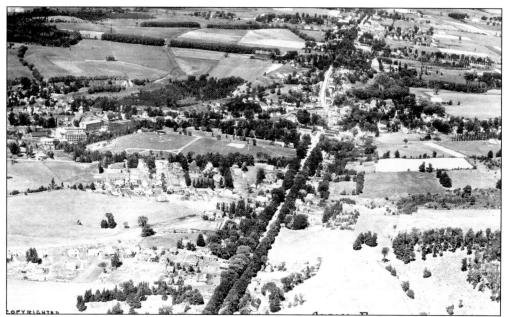

AERIAL VIEW, DERBY LINE, C. 1950. The mature trees along Main Street are clearly visible in this bird's-eye view of Derby Line, Vermont. Rock Island and Stanstead Plain, Quebec, to the north, are virtually indistinguishable from their Vermont neighbor, although Dufferin, Stanstead's main street, had already lost many of its trees by the time this photograph was taken. (Photograph by Harry Richardson.)

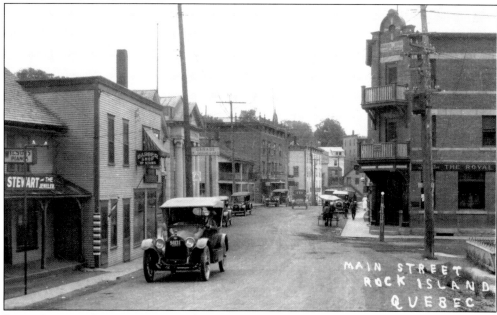

ROCK ISLAND, QUEBEC, 1920s. When this view of downtown Rock Island was taken, the village was a vibrant, bustling place. The buildings in the distance are across the Tomifobia River in Derby Line, Vermont. Rock Island and Stanstead Plain, Quebec, and Derby Line were so close—geographically, economically, and socially—that they were long referred to collectively as "the Three Villages."

STANSTEAD PLAIN, QUEBEC, C. 1915. Stanstead Plain was settled in the 1790s by New Englanders. By the early 1800s, the Quebec-Boston stage road brought increasing numbers of travelers. Hotels, a courthouse, an academy, and some splendid homes appeared. An unusual episode occurred in 1849, when political unrest in Stanstead County prompted over 1,400 people, many quite prominent, to call for annexation to the United States.

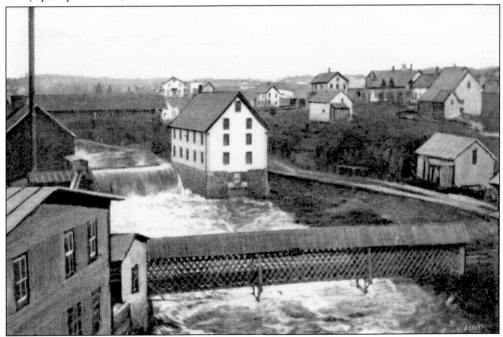

NORTH TROY, C. 1908. Thanks to the Missisquoi River, North Troy, Vermont, was home to several mills. The village also had two long, covered lattice bridges, both seen here. Several similar bridges were erected on the Canadian side of the border, possibly by the same builder.

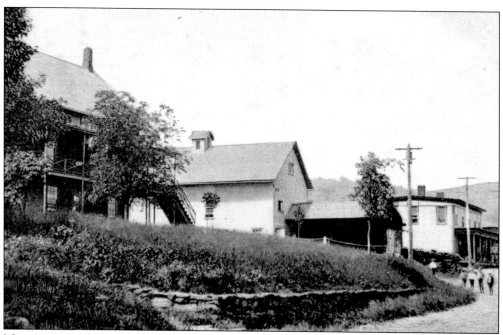

MANSONVILLE STATION (HIGHWATER), QUEBEC, C. 1908. Renamed Highwater in the early 1900s, Mansonville Station was a stop on the South Eastern Railway. Today Highwater is best known as a port of entry into Canada. North Troy, in Orleans County, is directly to the south.

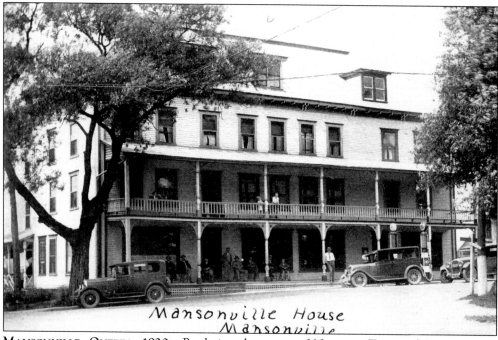

Mansonville House
Mansonville

MANSONVILLE, QUEBEC, 1930S. Bordering the towns of Newport, Troy, and Jay, Vermont, Mansonville is the largest village in Potton Township, which was first settled in the 1790s by United Empire Loyalists escaping persecution in the United States. Col. Hendrick Ruiter and his family, who settled in West Potton (Dunkin), were the first arrivals.

RICHFORD, C. 1908. Richford's position was dictated by the falls on the Missisquoi River. Among the industries attracted by the waterpower—and by the vast stands of forest in the surrounding countryside—were furniture manufacturers, such as the Sweat-Commings Company and the Richford Furniture Company. This image was published by Leighton and Valentine, New York.

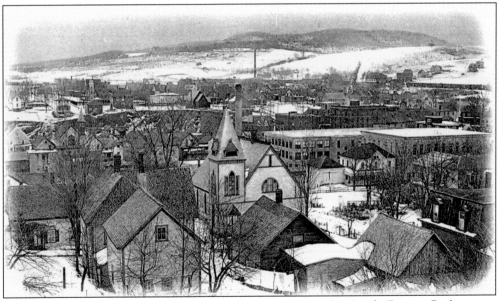

RICHFORD FROM SCHOOLHOUSE HILL, C. 1910. In 1873, the South Eastern Railway was completed from Farnham, Quebec, to Newport, Vermont. Richford found itself on a direct line from Montreal to the Atlantic. A second line, the Missisquoi Railroad, linked Richford to St. Albans. The railways transformed Richford from a sleepy village on the Canadian frontier to a prosperous industrial town. Wood products were the main industries.

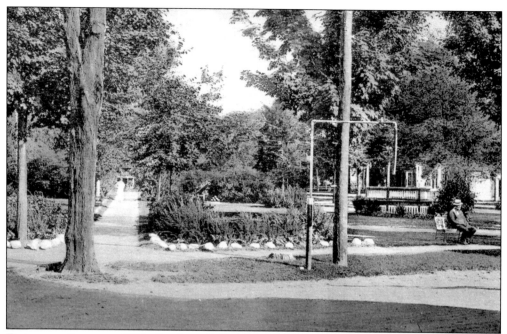

ENOSBURG FALLS, C. 1910. Enosburg Falls was once the patent medicine capital of Vermont. Local manufacturers sold mail-order cure-alls to gullible customers across the United States. This early postcard of Lincoln Park, at the heart of the village, was published by H. A. Giddings, Enosburg Falls.

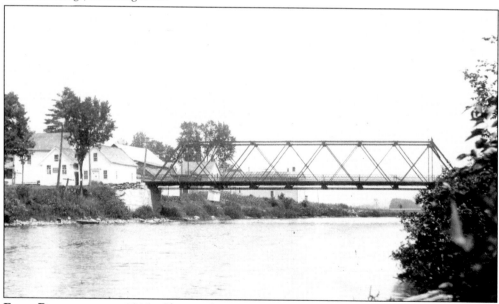

EAST BERKSHIRE, C. 1915. Chartered in 1781, Berkshire, Vermont, is a border town in Franklin County. Local librarian and dual citizen Heather McKeown senses a definite "personality on the border." She believes that Vermonters and their friends to the north "understand each other completely," and that the "acceptance of place, championing of individuality, [and] respecting of secrets are interwoven fibers" in this part of the world. (Photograph by the Eastern Illustrating Company.)

ALBURGH (FORMERLY ALBURG), 1940S. This town, on the Alburgh Tongue, a peninsula that juts into Lake Champlain from Quebec, is the northernmost community in Grand Isle, Vermont's smallest county. The town's northern limit is the Quebec border, a 7-mile (11-kilometer) stretch with customs near Noyan and Clarenceville, Quebec. South Alburgh, above, is at the south end of the peninsula. This image was published by Townview, Portland, Maine.

MONTGOMERY, 1970S. Montgomery, Vermont, was pioneered in 1793 by Capt. Joshua Clapp, a veteran of the Revolutionary War. The community is named after Gen. Richard Montgomery, who was killed in the unsuccessful attack on Quebec City in 1775. (Photograph by Matthew Farfan.)

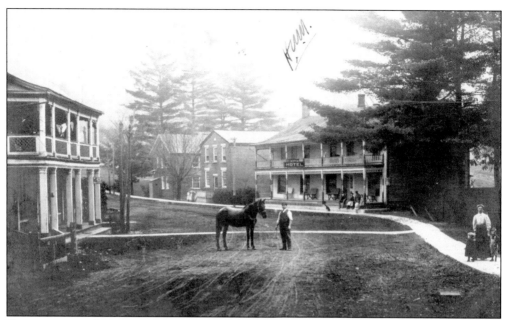

FRELIGHSBURG, QUEBEC, C. 1906. This village evolved around a gristmill, built in the 1790s. In 1800, the mill was purchased by Abram Freligh, who had arrived from New York State with his large family. Frelighsburg is about 3 miles (4.8 kilometers) from the border. The architecture is strongly reminiscent of that of Vermont.

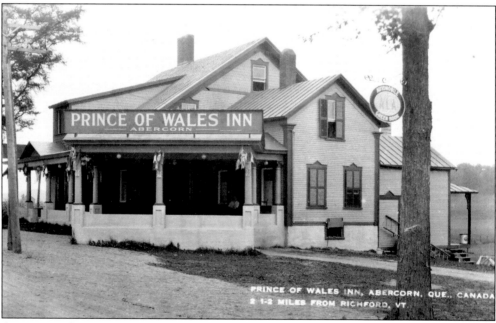

ABERCORN, QUEBEC, 1920s. Two and a half miles (four kilometers) from Richford, Abercorn is sandwiched between the Sutton Mountains to the east and Mount Pinnacle to the west. During Prohibition, Americans flocked here to indulge in one of their favorite pastimes—drinking. The Prince of Wales Inn, above, was one of several local drinking establishments.

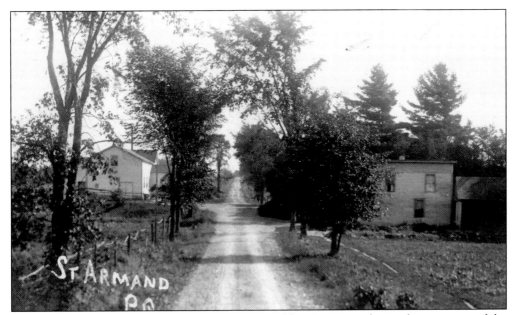

SAINT-ARMAND, QUEBEC, C. 1910. Bordering Franklin County in the southwest corner of the Eastern Townships, Saint-Armand was pioneered in the 1780s by Dutch United Empire Loyalists from Upstate New York and, later, by New Englanders. It is one of the oldest settlements north of the line.

ISLAND POND, 1870s. Island Pond's heyday began with the opening of the Grand Trunk Railway between Montreal and Portland, Maine, in 1853. Midway on North America's first international railway, the village was a service center for the railway for about a century. Situated in Essex County, Island Pond boasted some fine homes, including the Ladd residence, pictured here. (Photograph by Farmer Taylor.)

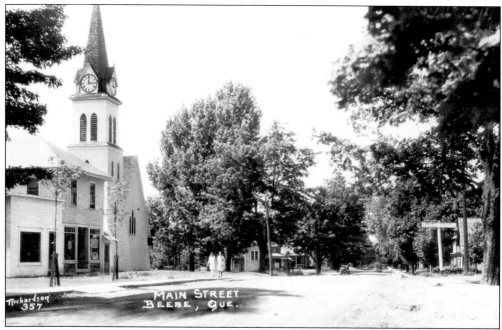

BEEBE PLAIN, VERMONT/BEEBE PLAIN, QUEBEC, 1920S. Situated astride the border, Beebe Plain was a backwater until the granite industry took shape in the late 1800s. Beebe's founder was Seba Beebe, a veteran of the Revolutionary War and a native of Connecticut. Convicted in Vermont of counterfeiting, Beebe's right ear was cut off and his forehead branded with a C. Starting afresh, in the 1790s, he moved to the border with his wife, Sarah, and their sons, David, Thomas, and Calvin. Over the years, Beebe Plain evolved into two distinct villages on opposite sides of the border. Beebe is known for its stone industry (below) and for its international street, Canusa. For many years, an international post office served both villages. (Above, photograph by Harry Richardson.)

CHARLES E. HASELTON

MANUFACTURER OF AND DEALER IN

LIGHT AND DARK GRAY GRANITES ROUGH AND FINISHED

ALSO MARBLE

BEEBE LIGHT GRANITE A SPECIALTY

FIRST-CLASS WORK GUARANTEED BEEBE, QUE. and VT.

CHARLESTON, 1870s. Chartered as Navy in 1780 and granted to naval officer Abraham Whipple and his associates, the town of Charleston (so named after 1825), Vermont, was settled in the early 1800s. Growth was slow, but in time, two villages—West Charleston and East Charleston—emerged on the Clyde River, which provided waterpower to several mills. (Photograph by Farmer Taylor.)

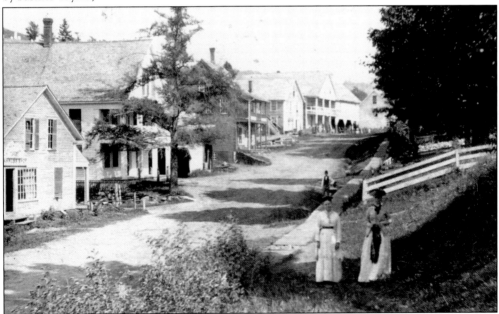

WEST CHARLESTON, 1870s. West Charleston boasted some elegant homes and businesses, including the Clyde River Hotel. This view of Main Street shows a harness shop (far left) and other commercial buildings in the distance. West Charleston was devastated by fire on May 19, 1924. Amazingly, a similar fate had befallen East Charleston only the day before. (Photograph by Farmer Taylor.)

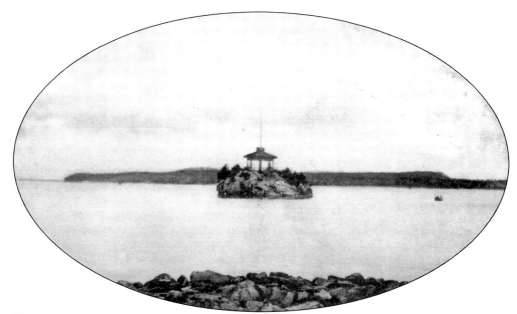

HIGHGATE SPRINGS, C. 1908. Highgate Springs takes its name from a mineral spring near Missisquoi Bay on Lake Champlain. Together with fishing and boating, the springs transformed the village into a popular summer destination. The Franklin House (1840s), and later the Highgate Springs Hotel, provided accommodations.

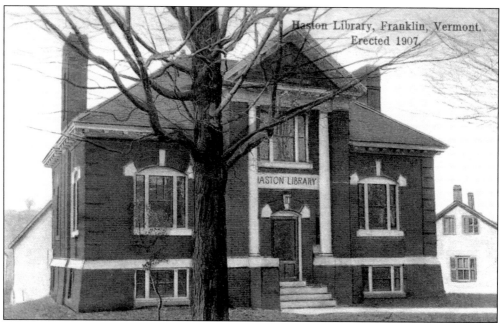

FRANKLIN, C. 1908. In his 1824 *Gazetteer of Vermont*, Zadock Thompson wrote that Franklin, Vermont, was "injured very much by a large pond which lies near the center." The pond in question, Lake Carmi, and the state park attached to it, are now the main local attractions. This view, published by F. L. Hopkins in Franklin, shows the Haston Library, which has served residents since 1907.

Two

AT THE LINE

In a 2008 interview with the author, retired U.S. Immigration inspector Keith Beadle, who worked in both Richford and Derby Line, Vermont, thought back upon his long career:

> I was at Immigration from 1972 to 2006. I enjoyed the work. After a while you developed a sixth sense. You'd know who wasn't telling the truth. I got to know the local people. Not all by name, but a lot of them—and the faces. You got to know their habits. You developed a trust with people – and I don't think it was misplaced trust. Back then we were encouraged to be friendly. That was the policy: be friendly and welcoming. We couldn't ignore the law, but we could use discretion.
>
> One time a family from Africa arrived, wanting to visit relatives they hadn't seen for years. They didn't have visas, and their relatives didn't have visas for Canada. I told them if they wanted to apply for entry, it would take me a while to complete the paperwork. Meanwhile they could have their relatives come and visit them in the waiting room while I processed the forms. The people arrived and they sat together for over an hour. Then I sent them home. So the law was enforced, but I used my discretion. But most of that discretion has been taken away now. . . . They used to call it the Immigration *Service* and the Customs *Service*. Now it's Customs and Border *Protection*. It's all about enforcement now.

Sentiments like these are shared by many who live and work along the border today. The terrorist attacks of September 11, 2001, changed the face of security across the United States and resulted in the creation of the Department of Homeland Security in 2003. Some contend that security should "trump trade," as Paul Cellucci, former U.S. ambassador to Canada, has said. Others, such as U.S. senator Patrick Leahy, believe the emphasis on security at the expense of all else will undermine the amity that exists between communities on opposite sides of the boundary. They seek a middle ground, whereby security is maintained, but without diminishing the bonds of friendship, commerce, and community that have existed for so long between Americans and Canadians.

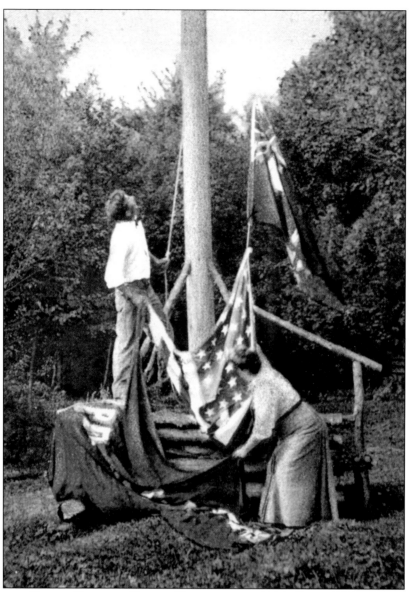

RAISING THE FLAGS, VERMONT-QUEBEC BOUNDARY, C. 1908. Since 1925, the International Boundary Commission has held jurisdiction over the line and the thousands of markers on land and water that separate the United States from its neighbor to the north. The International Boundary Commission inspects the boundary, repairs damaged markers, maintains a 20-foot-wide (6-meter-wide) vista through the forest, and regulates all construction within 10 feet (3 meters) of the line, including signs, pipelines, buildings, fences, and anything else that might obstruct the boundary line. Ensuring the boundary is clearly visible along its length is key to the International Boundary Commission's mission, and to the avoidance of disputes. A clear boundary facilitates the enforcement of customs, immigration, hunting and fishing, and other regulations; enables the accurate evaluation of property values (and of property and school taxes); and defines the limits of national, provincial, state, and municipal jurisdiction. The display of cross-border patriotism seen here might no longer be permitted today. This image was published by Bigelow's Pharmacy, Newport, Vermont.

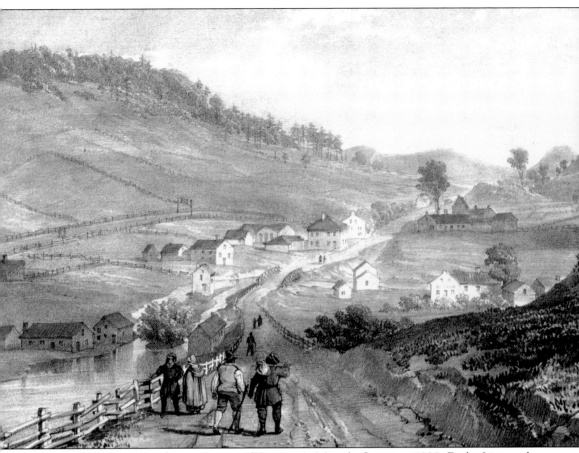

DERBY LINE, VERMONT/ROCK ISLAND (KILBORN'S MILLS), QUEBEC, 1827. Derby Line and Rock Island have been practically indistinguishable since they were settled two centuries ago. This 1836 engraving, from an earlier painting by surveyor Joseph Bouchette, shows the settlements from a hill overlooking the Tomifobia River. Several homes and businesses were built—some by chance, others by choice—astride the boundary. In the early 1800s, the boundary was moved slightly several times. This print indicated the "Old Province Line" and the "New Province Line," a few feet from each other. After the Webster-Ashburton Treaty of 1842, the boundary was moved again. Four years later, Canadian customs official James Thompson reported that chaos reigned as a result. The commissioners, he wrote, had "placed their post a few feet north of the original boundary in this neighbourhood, by which a store occupied by one Butler and then half on each side of the line is now altogether in the State of Vermont; and an iron foundry belonging to one Woolley similarly situated."

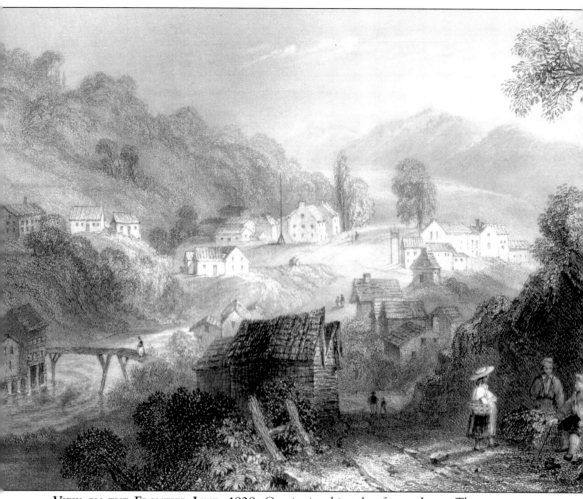

VIEW ON THE FRONTIER LINE, 1838. Continuing his tale of woe, James Thompson wrote that the commissioners intimated that "as soon as the boundary was accepted by the two governments, a proclamation would be issued, for the information and guidance of all parties. Since the completion of this survey. . . . Butler has entered into the patent medicine business, and become an agent for various parties in the neighbouring states . . . thereby giving every facility for parties in this Province to make purchases and evade duties. Butler claims to be altogether in the State of Vermont, which is indicated by the boundary post placed at the fence of his house by the commissioners, while Woolley whose foundry occupies the opposite corner of the road west and equally in the State of Vermont, asserts that his stoves and castings are cast in Canada, the new boundary not having been proclaimed by the two governments; and he (Woolley) is now preparing for extending his buildings northward that he may be as heretofore astride the Province line." This 1842 engraving by W. H. Bartlett, from an older drawing, was published at the time of the Webster-Ashburton Treaty.

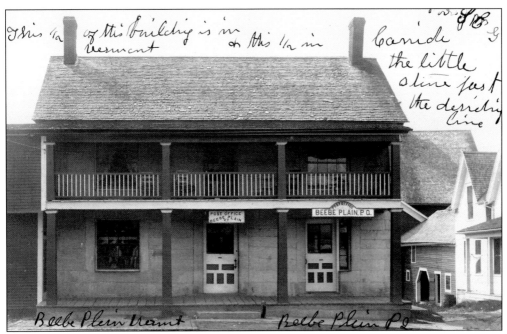

This ½ of this building is in Vermont & this ½ in Canada the little line just the dividing line

Beebe Plain Vermt Beebe Plain P O

ON THE LINE, BEEBE PLAIN, VERMONT/BEEBE PLAIN, QUEBEC, C. 1906. Originally a store, this building's location astride the boundary allowed merchant Horace Stewart to sell goods to clients in both countries without dealing with customs. Years later, his daughter, Martha Haskell, and her son, Horace, would finance the Haskell Library on the Derby Line/Rock Island border. In this way, profits made on one part of the border were reinvested philanthropically on another.

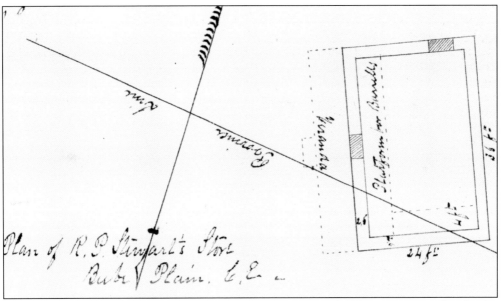

Plan of R. P. Stewart's Store Beebe Plain. C. E.

SURVEY, STEWART STORE, BEEBE PLAIN, 1859. Horace Stewart had his store surveyed so that he could prove he was only selling alcohol on the American side of the building. Local temperance laws were in effect in Canada at that time. This drawing is the work of Stewart's friend, surveyor Henry Martin. (Golden Rule Lodge collection.)

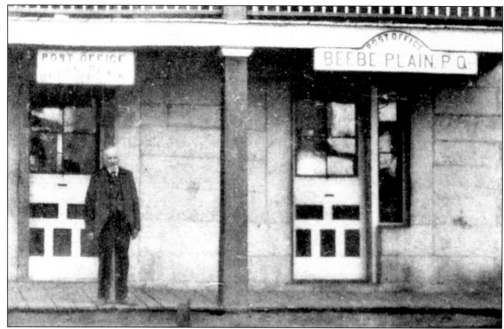

Two Doors, Two Countries, Beebe Plain, c. 1900. The Stewarts' unusual store was eventually converted into a post office. The "World's Only Double Post Office," as *Ripley's Believe It or Not* called it, functioned into the 20th century. It had two doors and two postal counters, each serving customers from a different country.

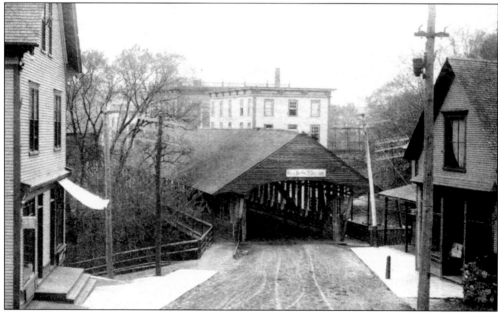

Line Bridge, Vermont-Quebec Border, c. 1910. The first bridge over the Tomifobia River, which effectively separated Derby Line from Canada, was built in 1802. The Line Bridge was an 1847 replacement. Built by American bridge builder Peter Paddleford, it survived until 1913. Retail shops operated on both sides of the bridge. Note the boundary marker, protruding through the sidewalk on the right. This image was published by Derby Line Studio.

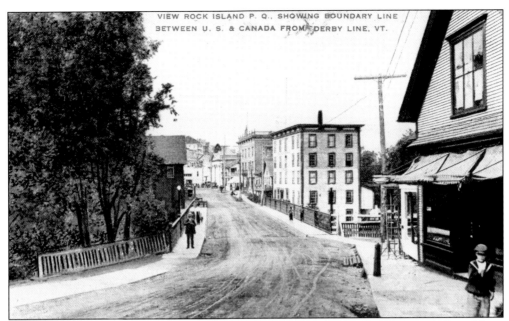

ROCK ISLAND, QUEBEC, FROM DERBY LINE, VERMONT, C. 1915. Derby Line trustee Perry Hunt, who grew up in Newport Center, believes the changing fortunes of business on either side of the border depend largely on the relative worth of the Canadian and American dollars. Most people, he thinks, will tolerate the "hassle of crossing" as long as they get a bargain on the other side. This image was published by J. T. Flint, Derby Line, Vermont.

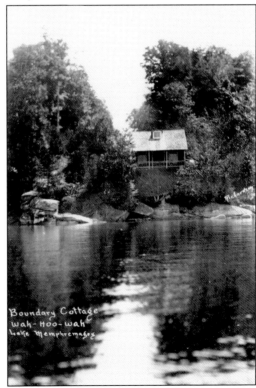

BOUNDARY COTTAGE, LAKE MEMPHREMAGOG, C. 1920. Many landmarks, both natural and man-made, distinguish the international boundary. This rustic Lake Memphremagog cottage was built directly on the line separating Derby, Vermont, from Stanstead Township, Quebec. (Photograph by Harry Richardson.)

37

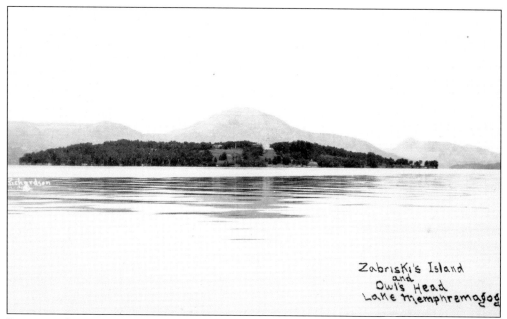

PROVINCE ISLAND, LAKE MEMPHREMAGOG, C. 1915. Province Island, the largest island on Memphremagog, takes its name from the province line, or border, that cuts across its southern tip. Most of the island is in Quebec, although a few acres at the southern tip are in Vermont. (Photograph by Harry Richardson.)

BOUNDARY, PROVINCE ISLAND, C. 1930. Province Island was once called Zabriskie Island, after Andrew Zabriskie, a wealthy New Yorker who built a mansion on the Canadian side of the island. The island was later owned by Benjamin Howard, of Beebe, Quebec, and named Howard's Island for a time. This view shows the boundary as it cuts across the island. On the right is Vermont; on the left is Quebec.

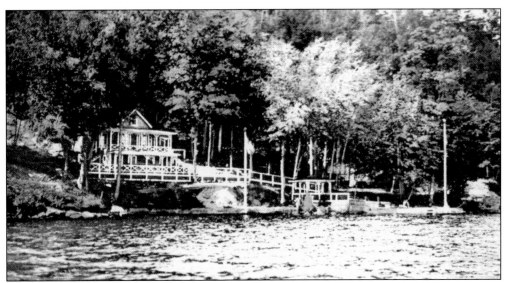

BOUNDARY PARK, MEMPHREMAGOG, 1920s. The boundary dividing "two great countries passes thru our Memphremagog region, leaving its markers on mainland and island; but there the division ceases. The hands of good fellowship span this imaginary line, uniting Canadians and Americans in interests that are identical." So wrote author William Bullock in 1926. The sentiment is still felt by many who inhabit different countries but share a common history and a similar culture. (Photograph by the Fletcher Company.)

MOTEL ADVERTISEMENT, DERBY CENTER, 1970s. Innumerable businesses along the border have been named after that imaginary line. The fact that the Border Motel was a whole 3 miles (4.8 kilometers) from Canada did not stop the owners from vaunting its proximity to the line. According to this postcard, "nowhere else do the peoples of two nations share a frontier so broad and free" than on the "friendliest border in the world."

COVERED BRIDGE, PROVINCE HILL, QUEBEC, C. 1960. Province Hill, near Troy, Vermont, was named for the province line. The community had a post office and, later, a customs. Little remains today apart from a few homes, a graveyard, a road that peters out at the border, and the covered bridge, above, built in 1896 in a style similar to that used by bridge builders in Vermont.

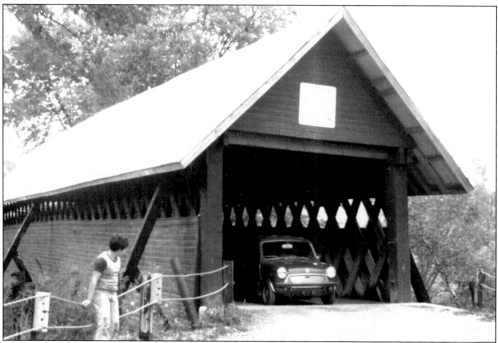

COVERED BRIDGE, TROY, 1970S. This is one of only a handful of covered bridges left in Orleans County. It was built in the town lattice style, much like the bridge in nearby Province Hill, Quebec. (Photograph by Matthew Farfan.)

MORSE'S LINE, VERMONT/MORSE'S LINE, QUEBEC, C. 1910. The hamlet of Morse's Line was home to James Monroe Hill, whose mercantile business spanned the two countries. Among Hill's ventures was a telephone company with over 110 miles (177 kilometers) of line and 400 subscribers. This view shows the Vermont side of Hill's property.

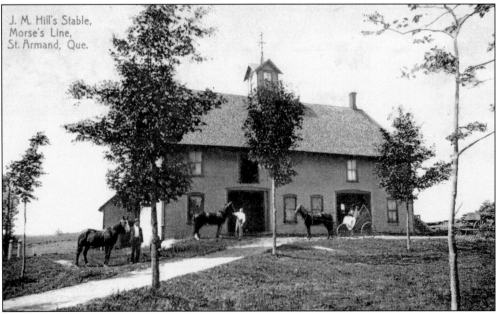

MORSE'S LINE, C. 1910. Before mailing this card in nearby Saint-Armand, the sender wrote simply, "I have skipped the States, am now in Canada." The card shows the elegant stables on the Canadian side of James Monroe Hill's property. Besides being a successful businessman, Hill served as president of the Missisquoi County Agricultural Society. This view and the preceding one were published by Hill in Morse's Line, Vermont.

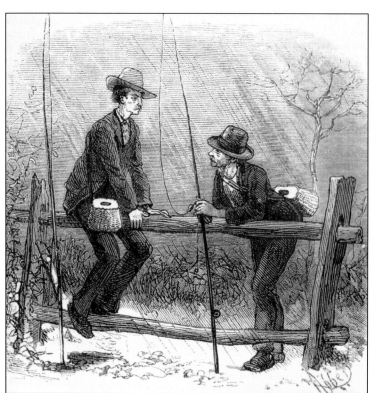

VERMONT-QUEBEC BORDER, 1874. Border security was a thing of the distant future when this engraving appeared in an 1874 *Harper's* magazine article titled "On the Boundary Line." Life was simpler, and helicopters, high-speed vehicles, satellites, sensors, and cameras to monitor who crossed the line were still a century away. Essentially smugglers had to be caught in the act.

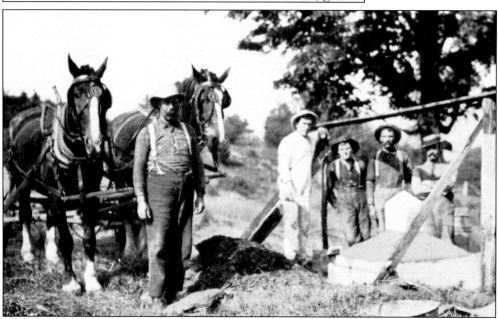

MONUMENT CONSTRUCTION, C. 1900. Surveying, vista clearing, and monument construction and repair have been regular chores along the Canada-U.S. border for over 200 years. The International Boundary Commission crew seen here, posing with a freshly set granite marker, was photographed on the Vermont-Quebec border just over a century ago. This image was published by the International Boundary Commission.

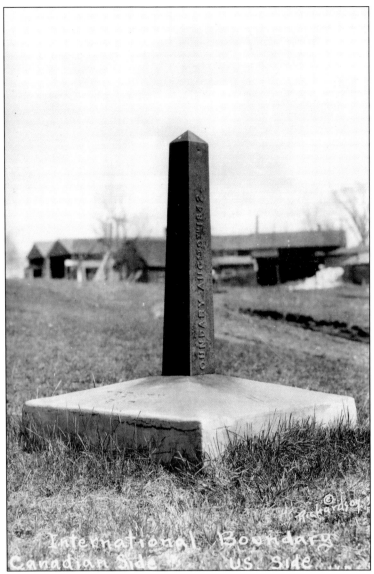

International Boundary
Canadian Side US Side

BOUNDARY MONUMENT, 1920s. The U.S.-Canada border is demarcated by over 8,600 monuments, all maintained by the International Boundary Commission. According to the International Boundary Commission, "most monuments are spaced so that at any boundary marker, the next one can be seen. . . . On the shores of Passamaquoddy Bay on the Atlantic, pairs of white triangular concrete pyramids mark the boundary course. Unique bronze disks set in concrete cylinders mark the Quebec-Maine border through the Highlands. Conical-shaped concrete monuments along the shorelines reference the boundary across the Great Lakes and connecting rivers. Over the prairies, the original mounds of sod have been replaced by cast iron and stainless steel posts. On the west coast, lighted steel towers provide range marks for the water boundary. Throughout other parts of the boundary, obelisk-shaped monuments and posts dot the vista from sea to sea. They are of varying heights and are made of materials which include granite, cast iron, bronze, stainless steel and aluminum bronze." Some of the original cast-iron monuments, such as the one above, were produced in Troy, Vermont, in the 1840s. (Photograph by Harry Richardson.)

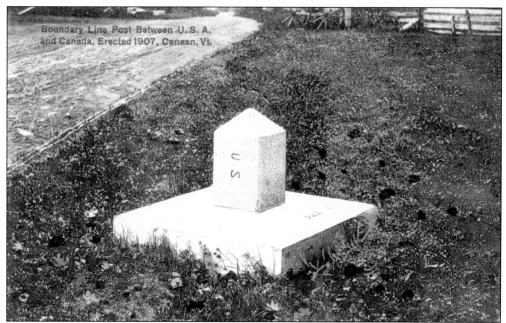

MONUMENT NO. 522, CANAAN-HEREFORD LINE, 1907. Every monument is numbered. This granite obelisk, erected in 1907, was of a type used in some places along the Vermont-Quebec border. This image was published by A. I. Farnham, Canaan, Vermont.

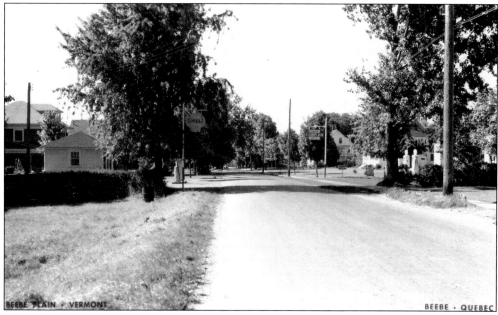

CANUSA STREET, BEEBE PLAIN, VERMONT/BEEBE PLAIN, QUEBEC, 1940S. Homes on the south side of Canusa are in Vermont; those on the north are in Quebec. Locals on either side must report to customs before they cross the street. "But when we first arrived here," says Canusa resident Francine Tougas, "our neighbors across the street came over with cake. We'd go back and forth for coffee. It should be like that everywhere!"

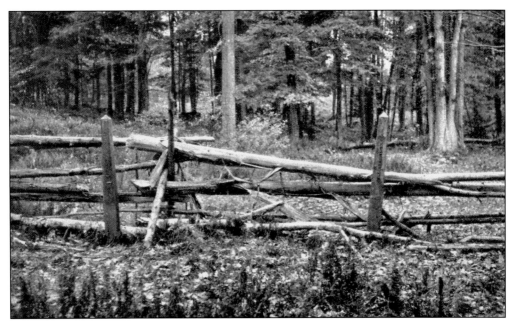

BOUNDARY, LAKE MEMPHREMAGOG, C. 1905. A local curiosity, this quaint old fence conveyed a sense of informality to the very official demarcation between two countries. The double cast-iron monuments indicated the presence of a nearby astronomical station. Some 595 feet (181 meters) to the north, inscriptions made by the 1845 survey crew are still visible on a rock outcrop. This image was published by Hugh C. Leighton, Portland, Maine.

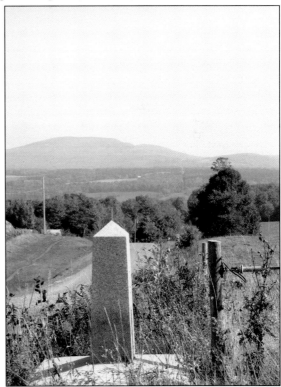

NEAR THE HOLLAND LINE. Other than a farm fence and a granite monument, there is little to indicate that this is the border between two of the world's largest countries. On the left is Stanstead East, Quebec; on the right is Derby, Vermont. In the distance, the boundary cuts through the countryside south of Mount Hereford. Along the way it forms the northern limits of Holland, Norton, and Canaan, Vermont. (Photograph by Matthew Farfan.)

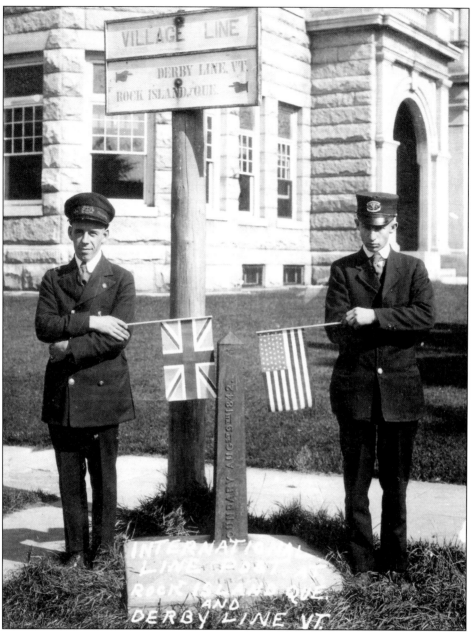

CUSTOMS OFFICERS, HASKELL LIBRARY, DERBY LINE/ROCK ISLAND, 1920S. The most often photographed monument on the Vermont-Quebec border is outside the Haskell Free Library and Opera House, which is itself, undoubtedly, the most famous "line house" in North America. Registered as a national historic site in both the United States and Canada, the Haskell was built astride the border so that it could provide culture to the communities in both countries. Completed in 1904 and funded by local philanthropists Martha Haskell and her son, Horace Stewart Haskell, the Haskell is cited as a symbol of friendship between two countries. An oddity, it is the only library in the United States with no books (they are on the Canadian side of the building); the only opera house with no stage (it, too, is in Canada); and the only library or opera house in Canada with no entrance (the door is in the United States).

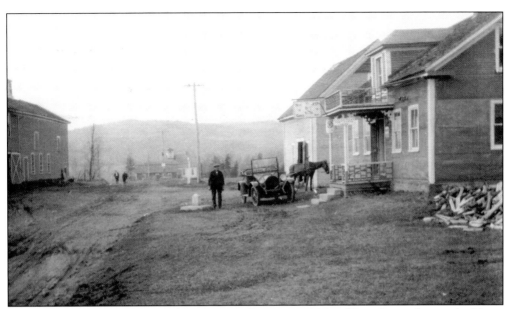

TAVERN, CANAAN, VERMONT/HEREFORD, QUEBEC, 1920s. "Line houses" were buildings constructed astride the border. Their heyday was during Prohibition in the United States. There were two line houses in Hereford. The sender of this postcard wrote, "At the left is part of the Line House where Joe, Stan and I went on a flying trip for beer. On the right is the Old Tavern where I got these cards." (Photograph by the Eastern Illustrating Company, Belfast, Maine.)

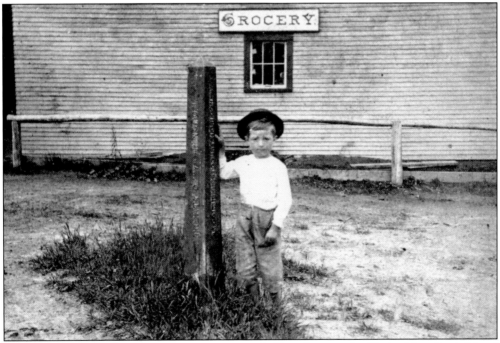

FRONTIER GROCERY, 1870s. This view was probably taken on the Derby Line–Rock Island border. The photographer, Farmer Taylor, was active in both Vermont and Quebec. (Photograph by Farmer Taylor.)

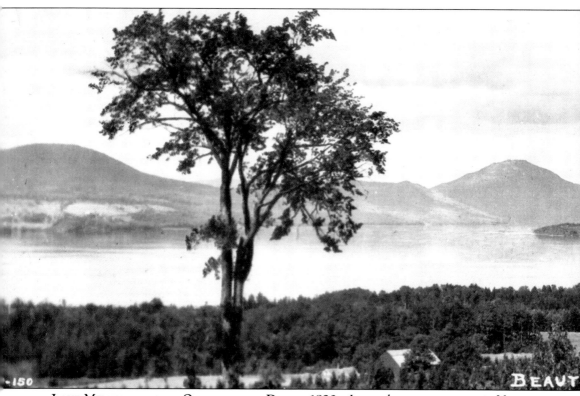

LAKE MEMPHREMAGOG, QUEBEC, FROM DERBY, 1920S. Its southernmost quarter in Vermont, Memphremagog's maximum depth is about 350 feet (107 meters). Dominating its shores are Bear, Owl's Head, Elephantis, and Orford Mountains—all in Canada. Before the arrival of the Europeans, Memphremagog was a canoe route for native peoples traveling on their seasonal migrations. Later it served as a highway for settlers moving into the Eastern Townships from

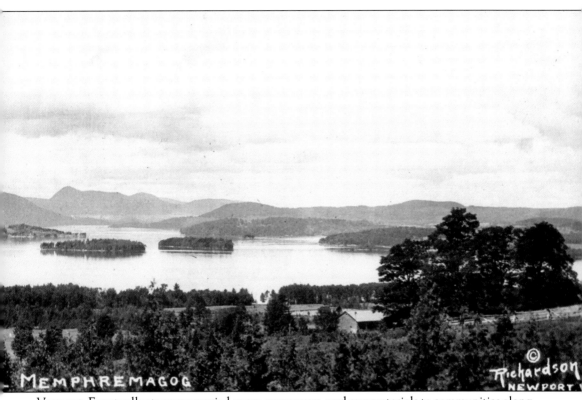

Vermont. Eventually steamers carried cargo, passengers, and raw materials to communities along its shores. Tourism grew, and the lake became famous for its hotels, fishing, boating, and scenery. Today Memphremagog is best known as a destination for cottagers and vacationers, and for its two largest communities, Newport, Vermont, at one end and Magog, Quebec, at the other. (Photograph by Harry Richardson.)

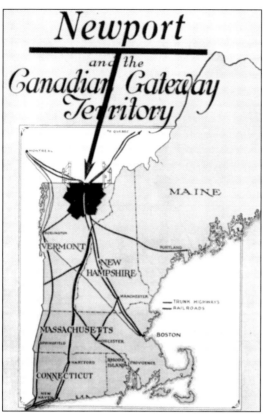

NEWPORT AND THE CANADIAN GATEWAY TERRITORY, C. 1928. The Gateway Airport tried to capitalize on Orleans County's proximity to Canada and its location on the flight path between Boston and Montreal. Newport was marketed as the "Key City" in this region, home to its own airport (in Derby) and to some of the most spectacular scenery around. The airport was short-lived; the scenery remained. (James Farfan collection.)

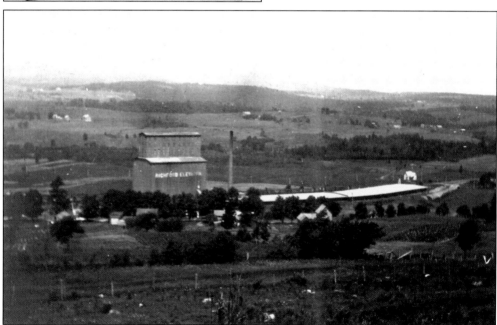

GRAIN ELEVATOR, RICHFORD, C. 1908. A note on the back of this photograph, showing Pinnacle Mountain and Canada in the distance, reads, "Elevator and grain sheds of the Canadian Pacific Railway, repositories for western products en route to New England states."

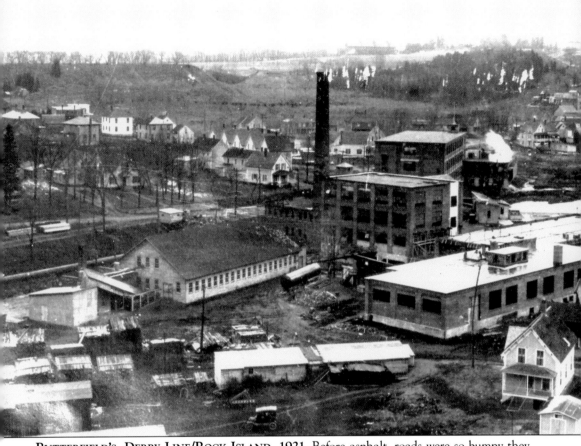

BUTTERFIELD'S, DERBY LINE/ROCK ISLAND, 1921. Before asphalt, roads were so bumpy they wore out the axels on carriages. Border resident Lewis Young invented a tool for fixing axels, which he marketed in Quebec and New England. Unable to keep up with the demand, he convinced F. D. Butterfield of Derby Line to become his partner, and the two set up shop in Rock Island in 1880. Eventually they moved to a location astride the Canada-U.S. border. Butterfield's, as the plant was called, grew to become the main employer in both communities. The factory spanned the Tomifobia River, which provided it with power via a turbine on the Vermont side of the plant. At its peak, Butterfield's employed nearly 800 people and produced a range of cutting tools, including taps, dies, drills, screw plates, and reamers. Following a labor dispute, the Canadian side of the factory closed in 1982, putting hundreds of people out of work.

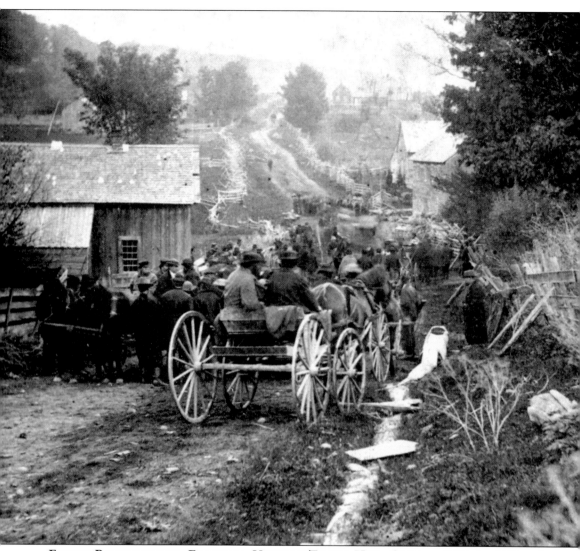

FENIAN BATTLEGROUND, FRANKLIN, VERMONT/ECCLES HILL, QUEBEC, 1870. In 1866 and 1870, Irish American extremists known as Fenians, who were seeking to pressure Great Britain to grant independence to Ireland, launched a series of armed raids into Canada from the United States. Two of these occurred on the Vermont-Quebec border. The first took place in 1866, when several hundred Fenians occupied Pigeon Hill, Saint-Armand, and Frelighsburg. After looting farms and intimidating residents, the Fenians retreated to Vermont when they heard the Canadian militia was approaching. A few stragglers were captured by the volunteer cavalry. A second raid took place at Eccles Hill in 1870. It proved equally disastrous for the 400 or so Fenians who were repulsed by a small force of militia and home guard. This photograph shows the curious that flocked to the site of what would prove to be the last "battle" to take place on the Quebec-Vermont border. (Photograph by T. G. Richardson.)

Three

FRIENDS AND NEIGHBORS

Lifetime border resident Octave "Jack" St-Sauveur of Stanstead, Quebec, shared some of his reminiscences with the author in 1998. Recalling his early childhood, he explained:

> I was born in 1916. We were brought up speaking French. Dad was an American, mother, a Canadian. When they didn't want us to hear what they were talking about, they'd talk English amongst themselves. But we had neighbors, and they had one son, just about my age, and being of the same age, we'd play together. But he was brought up in English and we were French. He wanted to learn French so he could play with us. But we caught on to speaking English a lot faster than he learned French. So eventually we'd play in English all the time, and that's where I got my start in English.

This story of the mingling of French and English, Canadian and American, is typical of many people living on the Vermont-Quebec border. Jack St-Sauveur's American father, whose family name was Domina, was born near Richford, Vermont. Jack's mother, a Couture, was French-Canadian, from the Eastern Townships. Jack was born and raised (in French) in Derby Line. He was baptized in Canada, where the priest persuaded his parents to christen him with the name, St-Sauveur, which "sounded more Catholic." Immigration laws at that time were less rigid than they are today, and the movement of families from one country to the other was simpler.

As an adult, Jack moved across the line to Rock Island, where he married a Canadian girl. He worked for much of his life at Butterfield's, a tool plant straddling the Canada-U.S. border, but later served as custodian of the equally international Haskell Opera House. A talented singer, Jack was eventually chosen to sing the national anthems of both countries before opening night crowds in the opera house, projecting his booming voice from a stage in Canada to an audience partly in the U.S. Jack, who lived for many years in an apartment building divided by the international boundary, is truly a citizen of the border.

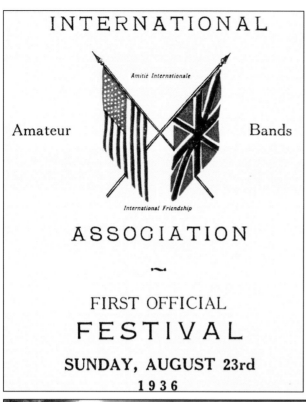

INTERNATIONAL

Amateur

ASSOCIATION

~

FIRST OFFICIAL

FESTIVAL

SUNDAY, AUGUST 23rd

1936

Amitié Internationale

International Friendship

Bands

INTERNATIONAL AMATEUR BANDS ASSOCIATION, DERBY LINE, 1936. Numerous local clubs and associations have boasted an international membership. Still active today is the Rotary Club of the Boundary, founded in 1935. Another, the International Amateur Bands Association, organized an annual festival in Derby Line. Bands from Vermont and Quebec competed. The association's motto was "International Friendship, Good Fellowship, Better Bands and Better Music." (James Farfan collection.)

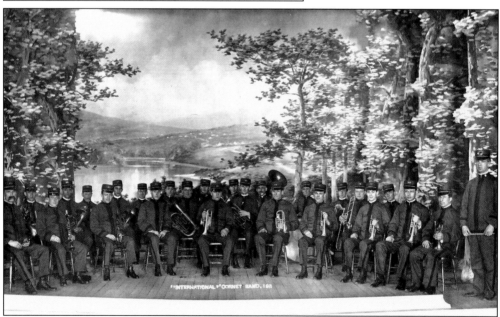

CONCERT, HASKELL OPERA HOUSE, 1911. The International Cornet Band, above, was composed of musicians from Vermont and Quebec. The stage upon which the musicians are sitting is in Canada. About half of the audience would have been sitting in the United States. Then, as now, neither performers nor patrons needed passports to enter the opera house. (Photograph by J. J. Parker.)

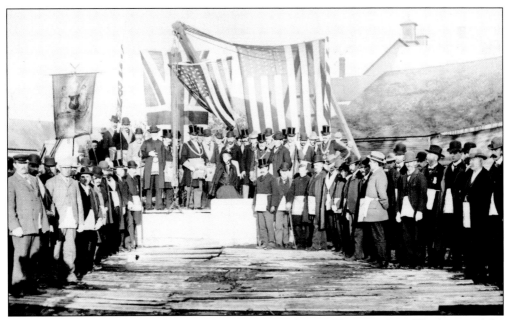

CORNERSTONE CEREMONY, HASKELL LIBRARY AND OPERA HOUSE, 1901. The laying of the Haskell's cornerstone was a major event on the border. The *Stanstead Journal* reported that 140 Masons from the two countries participated, among them Horace Stewart Haskell (seen here in a bowler hat, behind his mother, Martha, seated). The event attracted over 1,000 spectators. (Photograph by J. J. Parker.)

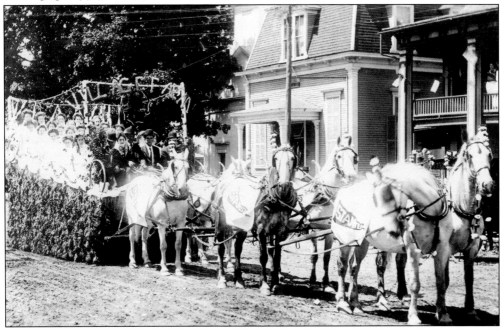

DOMINION DAY PARADE, DERBY LINE, VERMONT, 1909. Where else but on the border could one see a Dominion Day (now Canada Day) parade in the United States or a Fourth of July parade in Canada! This postcard depicts a prize-winning float from Stanstead, at the Derby Line Hotel. The message reads, "It was great fun for the girls who were in it."

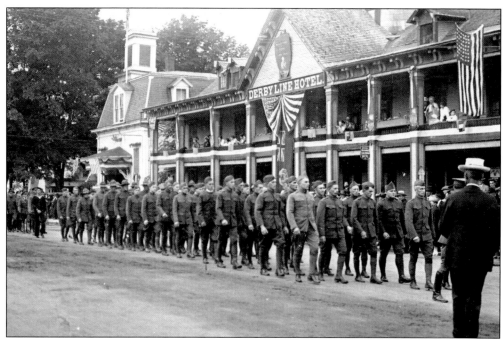

WELCOME HOME CANADA-U.S.A., DERBY LINE, VERMONT, 1919. This parade took place at the end of the First World War. In the background, ladies line the balcony of the Derby Line Hotel, the ideal place to cheer the soldiers from both countries as they march into Canada.

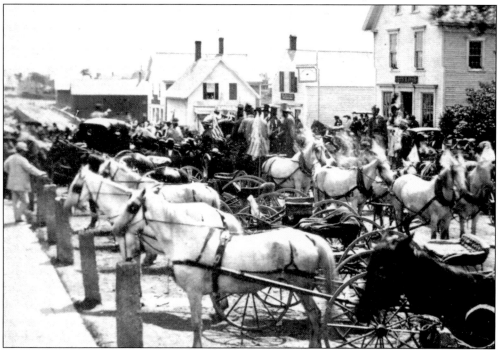

PARADE, NEWPORT, VERMONT, 1860S. The occasion for this parade is unknown. However, the flags and the wagonload of dignitaries in top hats suggest that it may have been a political event or perhaps a Fourth of July procession.

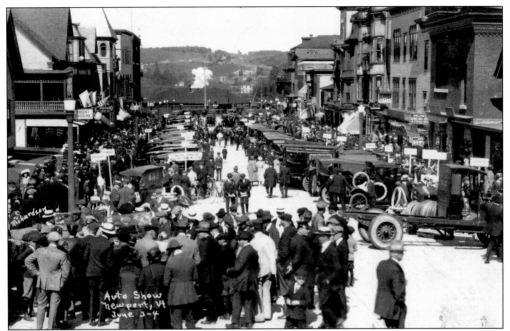

CAR SHOW, NEWPORT, 1920S. The era of the car had begun. This automobile show in Newport attracted spectators from all over northern Vermont and Canada. Displays featured the latest models, together with parts and accessories such as tires and transmissions. (Photograph by Harry Richardson.)

PARADE, ST. ALBANS, VERMONT, 1913. Nicknamed the "Railroad City" for its position on the Central Vermont Railway, St. Albans has had a long and checkered association with Canada. A base for smugglers in the early 1800s, the town was a refuge for French Canadian patriots fleeing the Canadian Rebellions of 1837–1838. In 1864, St. Albans was the scene of the northernmost engagement of the Civil War—the St. Albans Raid, launched from Canada by Confederate soldiers.

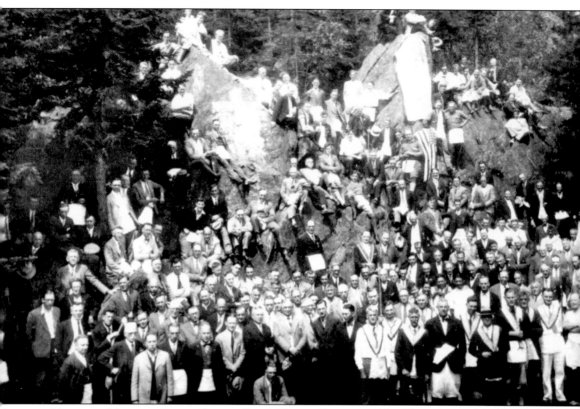

NATURAL MASONIC LODGE ROOM, OWL'S HEAD, QUEBEC, 1931. The origins of Golden Rule Lodge, of Stanstead, Quebec, extend back to 1803, the year Lively Stone Lodge was founded in Derby, Vermont. Golden Rule was an outgrowth of Lively Stone, which occupied a building straddling the Canada-U.S. border. Members entered through doors on opposite sides of the line. Golden Rule was chartered during the War of 1812, because wartime suspicions were being cast upon Masons from the opposing countries, who (being Masons) were meeting in secret, at night, on the border. The Derby Line Masons joined Golden Rule, and Lively Stone disappeared. To this day, Golden Rule's membership is international. The lodge is famous for its splendid hall and for the ceremony it holds each summer on Owl's Head Mountain. This event takes place in a natural amphitheater 2,425 feet (739 meters) above sea level and attracts Masons from around the world.

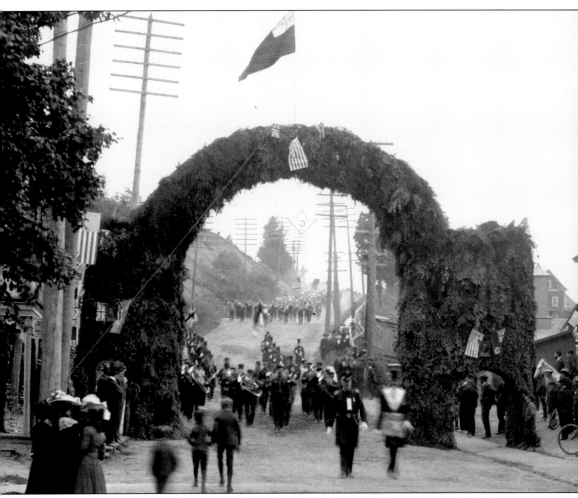

MASONIC PARADE, THREE VILLAGES, 1903. One of the largest celebrations on the border was Golden Rule Lodge's centennial parade. The event was hosted jointly by the Three Villages— Derby Line, Vermont, and Rock Island and Stanstead, Quebec. According to participant and historian Arthur Henry Moore, no such Masonic demonstration had ever been seen before in Canada. The streets were "spanned in four places by magnificent arches of evergreen." The arch in Rock Island (above) was decorated with the flags of Britain and the United States and with portraits of George and Martha Washington. Nearly 800 Masons from Vermont and Quebec marched from the Masonic hall in Stanstead through Rock Island and into Derby Line. The parade route was jammed.

MEMPHREMAGOG LODGE, NEWPORT, VERMONT, 1910. Chartered in 1865, Memphremagog Lodge is lavishly decorated in this photograph in honor of the Feast of St. John the Baptist. St. John the Baptist and St. John the Evangelist are regarded as the patron saints of Freemasonry. Over the years, a number of events have been celebrated jointly by Memphremagog Lodge and Golden Rule, in Quebec. (Photograph by E. L. Chaplin.)

INTERNATIONAL FRIENDSHIP, DERBY LINE/ROCK ISLAND, C. 1910. Friendship knows no boundaries. Then, as now, friends visit back and forth across the line. In this photograph, Sid Telford of Derby Line, Vermont, poses with his friend Henrietta Ball of Rock Island, Quebec.

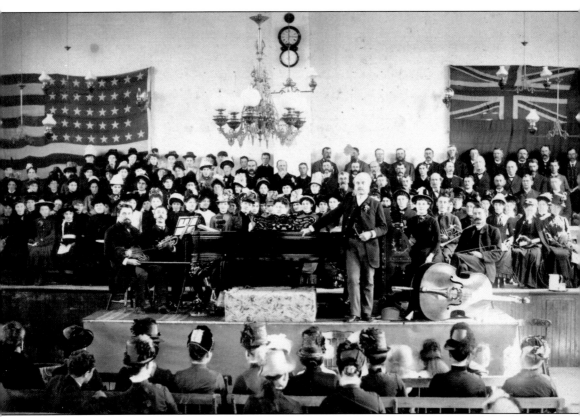

CHAUTAUQUA, JUNE 4–7, 1885. William Fisk Sherwin, seen here to the right of the piano, was a professor with the New England Conservatory of Music. He was also music director at the chautauqua movement near Chautauqua, New York. The movement, which combined adult education and cultural enrichment, was popular in rural America in the late 19th and early 20th centuries. As it grew, it spread beyond its original boundaries, with chautauqua assemblies traveling from town to town. Speakers lectured on subjects ranging from current events to spirituality. There was also entertainment, music, and prayer. Chautauqua assemblies were active on the Vermont-Quebec border. Judging by the flags, the assembly depicted here took place near the border, probably in the Coaticook area. (Photograph by M. D. Kilburn.)

BOUNDARY DISTRICT
SWARTHMORE CHAUTAUQUA

COOPERATING COMMUNITIES
BEEBE, STANSTEAD, ROCK ISLAND AND DERBY LINE

SUNDAY SERVICE, JULY 31, 1927

BAXTER PARK, DERBY LINE, VT.

BOUNDARY DISTRICT CHAUTAUQUA, DERBY LINE, 1927. A chautauqua was organized in Baxter Park in Derby Line, Vermont, in the summer of 1927 and involved the participation of the neighboring villages of Beebe, Stanstead Plain, and Rock Island, Quebec. This program was from the Sunday service, which featured Bible readings, hymns, and music by the International Band.

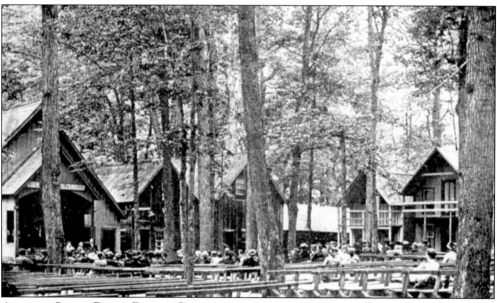

ADVENT CAMP, BEEBE PLAIN, QUEBEC, 1913. Many congregations along the border are composed of members from both countries. Some have even been served by pastors from the other country. Such was the case with Beebe's Advent Christian Church. An offshoot of this church, the Advent Campground (founded in 1874) attracted thousands of revivalists each summer. They came by train from Boston and New York to hear preaching and spiritual music at the camp.

STANSTEAD SOUTH CONGREGATIONALIST CHURCH, ROCK ISLAND, C. 1915. This church, now a part of the United Church of Canada, is only feet from the border. Some members of its congregation live in Derby Line, Vermont. This image was published by J. T. Flint, Derby Line.

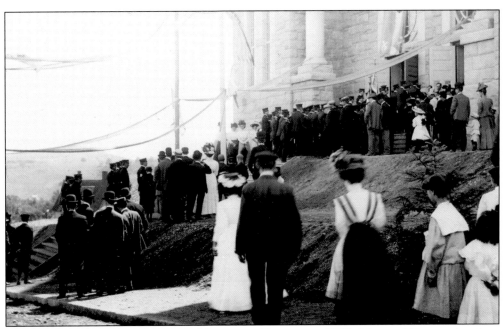

DEDICATION, CATHOLIC CHURCH, NEWPORT, VERMONT, 1909. Many of Newport's priests have been French Canadian. The construction of a new Catholic church, St. Mary's, on a hill overlooking the town was a massive undertaking. Built of granite in the Romanesque style, the church took six years to complete. According to historian Emily Nelson, the project was "a labor of love, sweat and tears that depleted energies and pocketbooks."

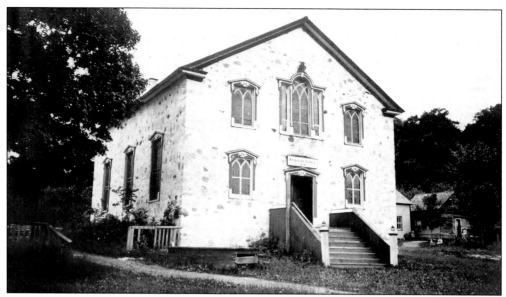

METHODIST CHURCH, PHILIPSBURG, QUEBEC, C. 1905. This church, built in 1819, is one of the oldest in the Eastern Townships. According to tradition, runaway slaves from the United States came to this area on the Underground Railroad in the 1860s, finding shelter in the homes of members of the congregation.

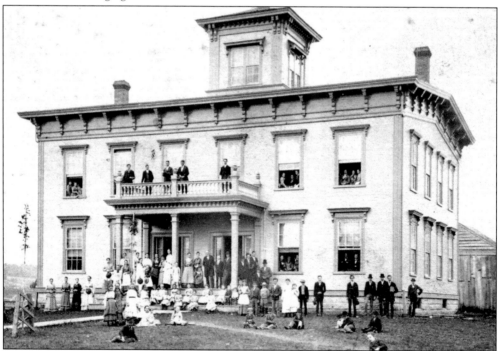

DERBY ACADEMY, 1870s. A class picture is always an occasion. In this view, the pupils and staff of Derby Academy are sporting their finest clothes. Established in 1845, Derby Academy was a respected boarding school. Students hailed from around Orleans County and elsewhere. According to an 1852 catalog, 40 of the 171 students were from across the line. (Photograph by Farmer Taylor.)

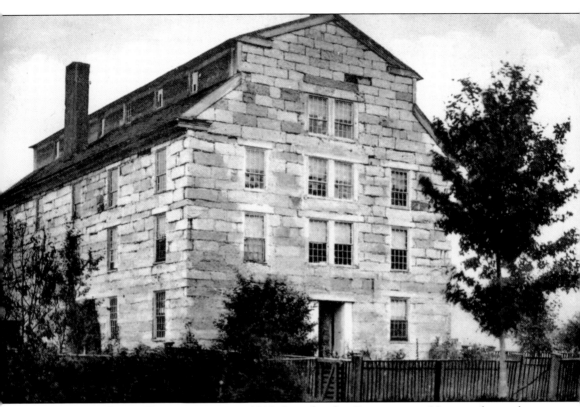

OLD STONE HOUSE, BROWNINGTON, C. 1910. In its heyday, Brownington, Vermont, boasted a courthouse, a stagecoach inn, and the Orleans County Grammar School, which attracted students from miles around. The Old Stone House was built as a dormitory for the school. Completed in 1836, it was constructed entirely of granite quarried in nearby fields. According to tradition, Athenian Hall, as it was then called, was the work of one man, Rev. Alexander Lucius Twilight, the school's principal and teacher. The school operated until 1859, by which time Brownington was becoming a backwater. Since 1918, the Old Stone House has been the property of the Orleans County Historical Society. For his part, Twilight is remembered as an inspiring educator, as the first African American college graduate, and as the first African American state legislator. This image was published by Austin's Pharmacy, Barton, Vermont.

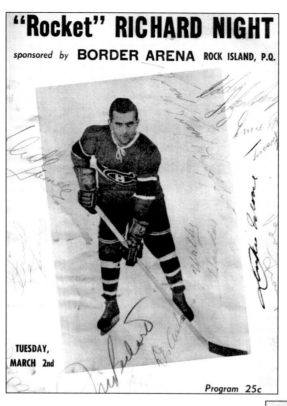

"Rocket" RICHARD NIGHT

sponsored by **BORDER ARENA** ROCK ISLAND, P.Q.

TUESDAY,
MARCH 2nd

Program 25c

BORDER ARENA, ROCK ISLAND, 1954.
This arena welcomed skaters from both sides of the line. Management included the mayors of Stanstead, Rock Island, and Beebe, Quebec, and a trustee from Derby Line, Vermont. On March 2, 1954, a Maurice Richard Night was held to inaugurate the rink. Several NHL hockey players, including the "Rocket" himself, were on hand for a friendly match with the locals. (James Farfan collection.)

BORDER THEATRE

ROCK ISLAND, QUE.

Sun, Mon, and Tues, Oct. 16, 17 & 18

(Night Shows 6 and 8 p.m. United States Time)
(7 and 9 p.m. Rock Island Time)

Cary Grant and Ann Sheridan, starring in

"I WAS A MALE WAR BRIDE"

Sunday Matinee 2:45 p.m 1:45 United States Time.

Wed. and Thur. Oct. 19 & 20

(Night Shows 6 and 8 p.m. United States Time)
(7 and 9 p.m. Rock Island Time)

☞ Here is a Great Picture! ☜

Gary Cooper and Jane Wyatt, starring in

"TASK FORCE"

☞ "Excellent in every way." M. P. Herald.

Latest News Events. Technicolor Short Subjects.

Fri. and Sat. Oct. 21 & 22

DeLuxe Two-Feature Show.
Wayne Morris and Janis Paige, in

"THE HOUSE ACROSS THE STREET"

AND

"FATHER WAS A FULLBACK"

Fred MacMurray and Maureen O'Hara.

Special Schedule Fridays and Saturdays Only: First Picture 7:00 p.m. Second Picture 8:15 p.m; First Picture (repeated) 9:30 p.m. Last Complete Show 8:15 p.m.
United States Times 6 p.m., 7:15 p.m. and 8:30 p.m. respectively

BORDER THEATRE, ROCK ISLAND, 1949.
The Border Theatre, which catered to an international clientele, was gutted by fire in 1918 but was soon rebuilt. This handbill dates from 1949 when Cary Grant was a star. Note the show times listed in both "Rock Island Time" and "United States Time," the two sides of the line being at that time in different time zones.

DERBY PORT DRIVE-IN, DERBY, 1960S. Bumper stickers like this one were once a common sight on cars throughout the border area. Only minutes from the border, the drive-in in Derby, Vermont, was a magnet for Canadians and Americans alike. It operated every summer from about 1950 to 1985, specializing in family movies, and is fondly remembered by its former patrons.

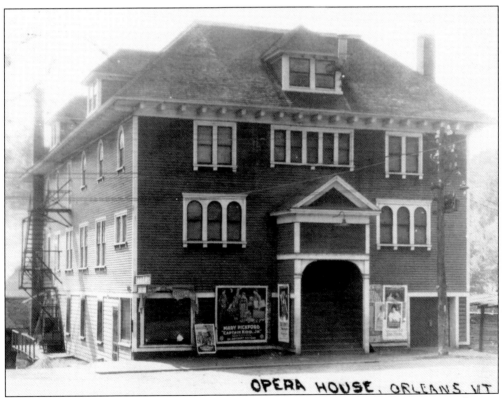

OPERA HOUSE, ORLEANS, C. 1920. With the advent of motion pictures, many opera houses switched from live entertainment to movies. Some featured both stage performances and films. Others disappeared altogether. When this photograph was taken, the opera house in Orleans was featuring *Captain Kidd, Jr.*, a silent movie starring Mary Pickford.

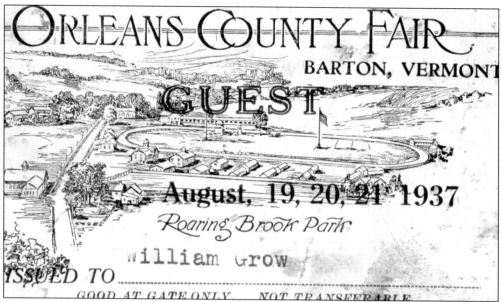

ORLEANS COUNTY FAIR, BARTON, VERMONT, 1937. The Orleans County Fair dates back to 1867. Combining traditional agricultural displays and livestock competitions with modern entertainment, such as live shows, rides, and a demolition derby, it attracts visitors from all over the Northeast Kingdom and Canada.

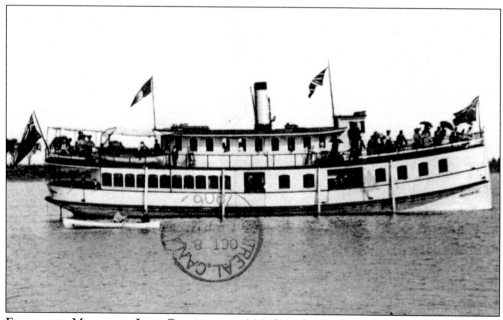

EXCURSION, *MISSISQUOI*, LAKE CHAMPLAIN, 1906. Capt. Benjamin Naylor piloted the *Missisquoi* for the Richelieu River Steamship Company at the dawn of the 20th century. The steamer carried passengers and goods around the north end of Lake Champlain and up the connecting Richelieu River, in Quebec. This image was published by Pinsonneault, St. Jean, Quebec.

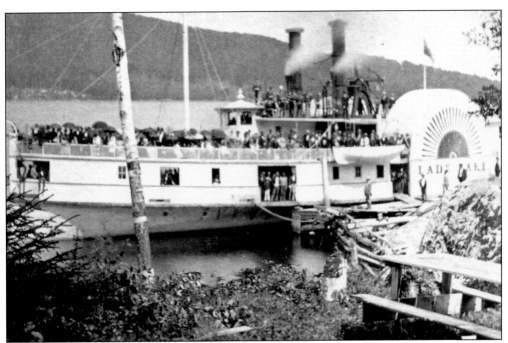

EXCURSION, *LADY OF THE LAKE*, LAKE MEMPHREMAGOG, C. 1880. The *Lady of the Lake's* engine and boilers were built in Montreal, but her hull was manufactured in Scotland and shipped in sections across the Atlantic. Upon arrival, the sections were transported by train to Sherbrooke and from Sherbrooke by teams to Magog where everything was assembled by crews from Montreal and Scotland. (Photograph by D. A. Clifford.)

STEAMER
Lady of the Lake.

EXCURSION.

TICKET, *LADY OF THE LAKE*, C. 1880. Steamer excursions on Memphremagog were immensely popular. Several vessels have operated on this international lake. The best known was the *Lady of the Lake*, launched amid much fanfare in Magog, Quebec, in 1867. The ship has since come to symbolize the glory days of steam navigation on the lake.

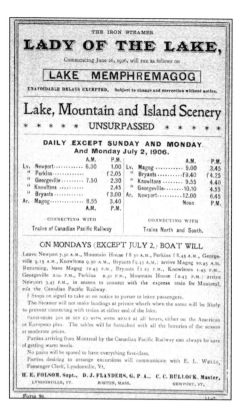

THE IRON STEAMER

LADY OF THE LAKE,

Commencing June 26, 1906, will run as follows on

LAKE MEMPHREMAGOG

UNAVOIDABLE DELAYS EXCEPTED. Subject to change and correction without notice.

Lake, Mountain and Island Scenery

* * * * UNSURPASSED * * * *

DAILY EXCEPT SUNDAY AND MONDAY.
And Monday July 2, 1906.

	A.M.	P.M.		A.M.	P.M.
Lv. Newport	6.30	1.00	Lv. Magog	9.00	3.45
" Perkins		f 2.05	" Bryants	f9.40	f 4.25
" Georgeville	7.50	2.30	" Knowltons	9.55	4.40
" Knowltons		2.45	" Georgeville	10.10	4.55
" Bryants		f 3.00	Ar. Newport	12.00	6.45
Ar. Magog	8.55	3.40		Noon.	P.M.
	A.M.	P.M.			

CONNECTING WITH	CONNECTING WITH
Trains of Canadian Pacific Railway	Trains North and South.

ON MONDAYS (EXCEPT JULY 2,) BOAT WILL

Leave Newport 7.30 A.M., Mountain House f 8 30 A.M., Perkins f 8.45 A.M., George-ville 9.15 A.M., Knowltons 9.30 A.M., Bryants f9.45 A.M.; arrive Magog 10.45 A.M. Returning, leave Magog 12.45 P.M., Bryants f1.25 P.M., Knowltons 1.45 P.M., Georgeville 2.00 P.M., Perkins 2.30 P.M., Mountain House f 2.45 P.M.; arrive Newport 3.45 P.M., in season to connect with the express train for Montreal, via the Canadian Pacific Railway.

f Stops on signal to take or on notice to purser to leave passengers.

The Steamer will not make landings at private wharfs when the same will be likely to prevent connecting with trains at either end of the lake.

PASSENGERS CAN BE SERVED WITH WARM MEALS at all hours, either on the American or European plan. The tables will be furnished with all the luxuries of the season at moderate prices.

Parties arriving from Montreal by the Canadian Pacific Railway can always be sure of getting warm meals.

No pains will be spared to have everything first-class.

Parties desiring to arrange excursions will communicate with E. L. WELLS, Passenger Clerk, Lyndonville, Vt.

H. E. FOLSOM, Supt., D. J. FLANDERS, G. P. A., C. C. BULLOCK, Master,
LYNDONVILLE, VT. BOSTON, MASS. NEWPORT, VT.

Form 89.

SCHEDULE, *LADY OF THE LAKE*, 1906. The *Lady of the Lake* traveled twice daily up and down Memphremagog, stopping at public docks along the way. Schedules were synchronized with train arrivals and departures in Newport, Vermont, and Magog, Quebec, at opposite ends of the lake. Passengers arriving from Montreal by the Canadian Pacific Railway could "always be sure of getting warm meals" and "no pains were spared to have everything first-class."

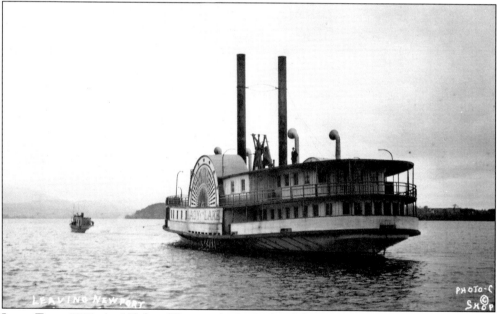

LAST TRIP, 1917. At 167 feet (51 meters), the *Lady of the Lake* was licensed to carry up to 666 passengers in 1914. With the advent of the automobile, however, the demand for tickets waned. In 1915, the boat was taken out of service. Two years later, she was towed to Magog and scrapped. That last trip must have been a melancholy one for the lone passenger on the deck in this photograph. (Photograph by Photo-Craft.)

Four

CROSSING THE LINE

In 2008, Beebe, Quebec, resident George Buckland told the author about an old customshouse in Lineboro, not far from his home on the North Derby Road:

> The customs has been closed for years, but the road and railway tracks that crossed the border there were only blocked off a few years ago. I used to sit outside and watch people driving across at night. They were smuggling. Once I was walking my dog and I heard people arguing on the Vermont side. I thought I recognized the voices, so I went over to see what was going on. It was a guy I knew and his wife. Someone had delivered a piano for them to the Quebec line. They had borrowed a railway cart from a nearby shed. When I got there, they were trying to hoist the piano onto the cart, but the man's wife couldn't lift her end. They asked me to give them a hand, so I did—just to be neighborly. We got the piano onto the cart, and I watched them as they headed up the tracks into Canada.

Tales like these are the stuff of legend in towns up and down the border. Indeed, they help make living in this part of the world interesting and, occasionally, entertaining. Of course, improvements in technology, greater numbers of customs and law enforcement agents, and heightened demands for security, have all contributed to a tightening of the border in recent years by both countries. Such measures have probably curtailed the amount of amateur smuggling, but the professionals will no doubt keep coming up with creative ways to cross illegally. The challenge for law enforcement agencies will be to think even more creatively.

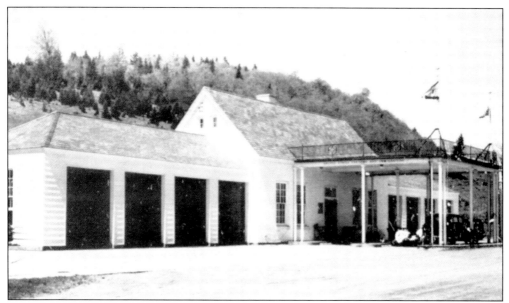

CUSTOMS AND IMMIGRATION, CANAAN, VERMONT, 1940S. After the Revolution, the U.S. government realized that the fledgling republic was in need of money. On July 4, 1789, George Washington signed the Tariff Act, which enabled the federal government to collect duties on imported goods. The Customs Department was created soon after. For over a century, this department funded much of the country's government and infrastructure. This image was published by Fairbanks, Brookline, Massachusetts.

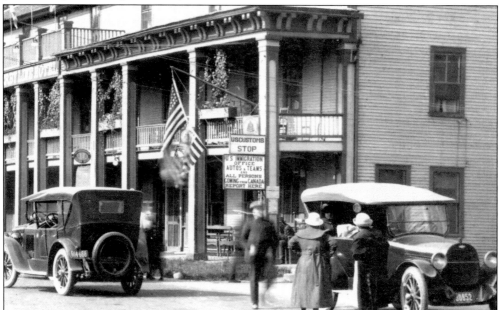

INSPECTION, DERBY LINE, 1920S. Gradually customs offices opened in selected villages along the border. At first, there were far fewer ports of entry than there were border crossings, or even villages. People importing goods were expected to report to the nearest office and pay the duty. Not surprisingly, many ignored the regulations. In 1824, the *Vermont Gazetteer* described Derby as a "port of entry," so a customshouse was operating there from at least that date.

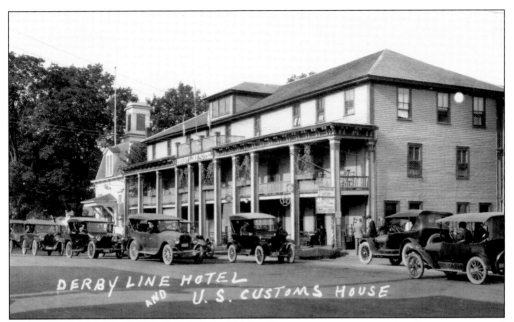

DERBY LINE HOTEL AND U.S. CUSTOMS HOUSE

DERBY LINE HOTEL/U.S. CUSTOMS, 1920S. It was common practice for customs and immigration to rent space for their ports of entry. Offices could be found in hotels, shops, and just about anywhere convenient and relatively close to the border. Most of the customshouses seen today date from the 20th century. For years, Derby Line Customs and Immigration was located in the hotel.

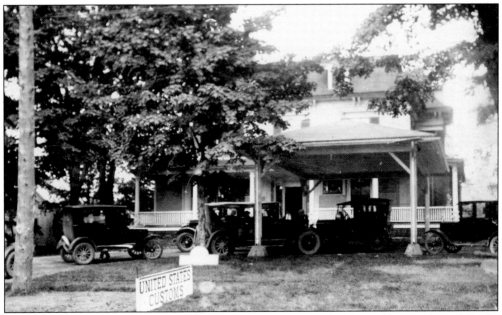

UNITED STATES CUSTOMS

TEMPORARY CUSTOMS, DERBY LINE, 1926. Increasing cross-border traffic transformed Derby Line into a noisy, congested village, limiting access to the hotel and adjacent buildings. The government's solution was to move the customs temporarily across the street into the Foster mansion (above), purchase and demolish the old hotel, and, in 1931, build a modern customs facility in its place.

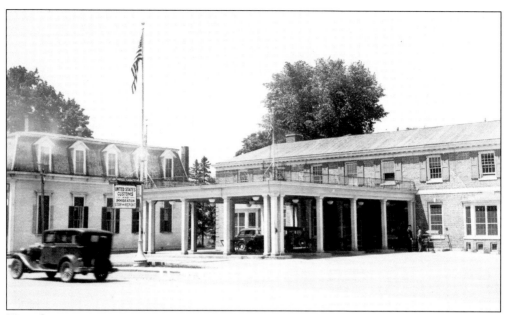

NEW CUSTOMS AND IMMIGRATION, DERBY LINE, VERMONT, 1930S. This photograph was taken shortly after the new building was completed. Before the September 11, 2001, terrorist attacks, it was routine for border guards to allow locals they recognized to enter the United States with a smile and a wave.

AMERICAN HOUSE, RICHFORD, VERMONT, C. 1900. This hotel was a stop for many travelers entering the United States. Today, three border crossings serve the area—Richford, Pinnacle, and East Richford. Many inspectors started their careers working at crossings like these during the summer. Retired inspector Keith Beadle taught high school math until he realized that border guards made more money. "Starting in 1972," he says, "I worked several summers for Immigration in Richford before taking a full-time job with them in Derby Line."

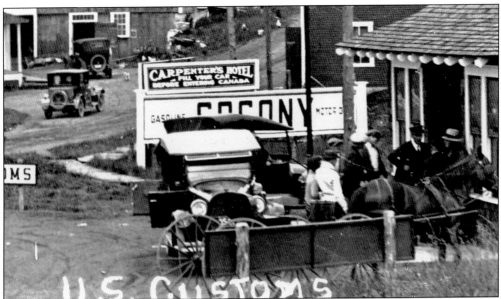

CUSTOMS, NORTON, VERMONT, 1920S. Over two centuries, border residents have amassed a considerable folklore around smuggling. Whiskey conveyed through a garden hose across a backyard, exotic animals hidden in overcoats, alarm clocks tucked under dresses (and ringing at just the wrong moment!), contraband cigarettes by the truckload, escapades through the woods, and high-speed chases are the subject of many tales. Few locals, of course, would admit (publicly, at least) to smuggling.

"COMING OVER THE LINE," C. 1920. This cartoon of a man crossing the border with a jug of liquor, a parcel under his arm, and pursued by a machine-gun-toting border guard, is from a postcard titled "What the Summer Boarder Expects to Find in Vermont." Other scenes included a cow on a treadmill, its udder connected to a butter machine; a woman "milking" a maple tree; and a village idiot. The postcard was published by Frank W. Swallow, Exeter, New Hampshire.

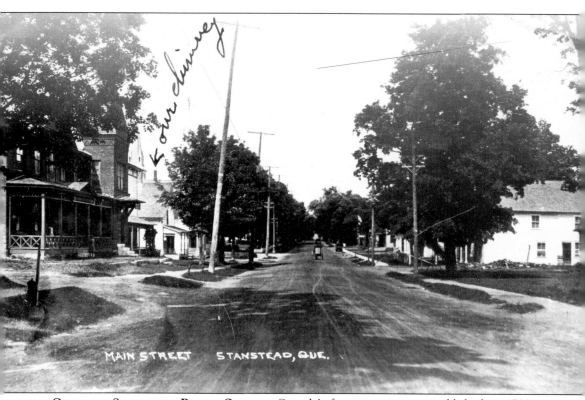

MAIN STREET STANSTEAD, QUE.

CUSTOMS, STANSTEAD PLAIN, QUEBEC. Canada's first customs was established in 1788 in Saint-Jean, on the Richelieu River, a trade route between Canada and its neighbors to the south. Intended to regulate the flow of goods crossing the border, the port was manned by British troops. For years there was no customs in the Eastern Townships, the population being too sparse to warrant the expense. In 1821, however, an office was opened in Stanstead. The building on the left of this photograph housed the customs for years. Unfortunately, the border was in Rock Island, over a mile (1.5 kilometers) to the south. It was the 20th century before a customs was opened with a view of the actual border. Meanwhile contraband flowed almost unchecked into Canada. Not surprisingly, the situation provoked complaints from those charged with enforcing the law. In 1852, collector James Thompson reported that smuggling was a way of life in the community and that agents had "ceased to be useful from the ill treatment of the smugglers and the community or the unprofitableness of the occupation." (Photograph by the Fletcher Company.)

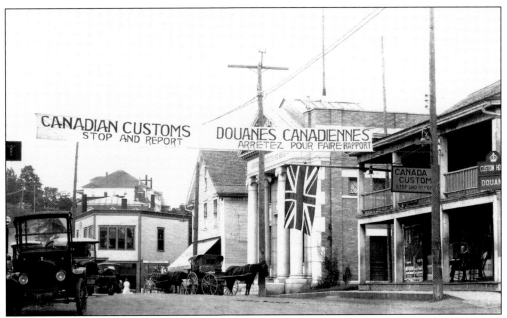

STOP AND REPORT! In 1909, Canada Customs moved its offices from Stanstead Plain to Rock Island. Although it was now much closer to the border, for several years to come it would still have no view of it. It was only in 1913 that the customs moved into the Porter and Wiley building, seen here. A banner over Main Street left no doubt what country this was! (Photograph by Harry Richardson.)

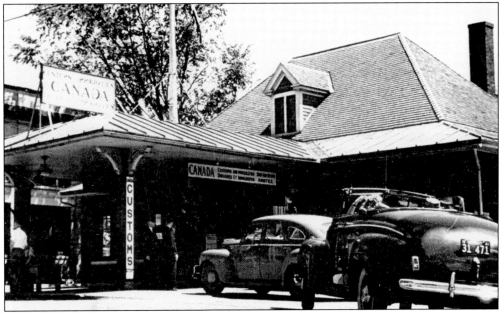

CUSTOMS AND IMMIGRATION, ROCK ISLAND, 1940s. Border residents have learned to take customs formalities in their stride. After nearly two centuries, they are used to the (usually) brief delay they experience when crossing. Most see the customs as a relatively minor inconvenience that will not deter them from shopping or visiting a friend across the line. This image was published by Brown's Drug Store, Derby Line, Vermont.

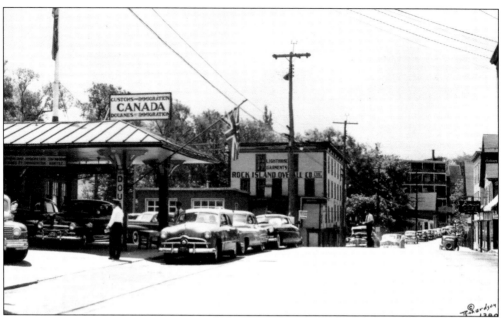

TRAFFIC JAM, C. 1950. Before the completion in 1963 of Autoroute 55 and its American counterpart, Interstate 91, with their large, modern customs and immigration facilities, north- and south-bound traffic flowed through Derby Line, Vermont, and Rock Island, Quebec, (above). On holidays and during the summer, this caused enormous traffic jams at the small local customs offices and circulation and parking headaches for residents. (Photograph by Harry Richardson.)

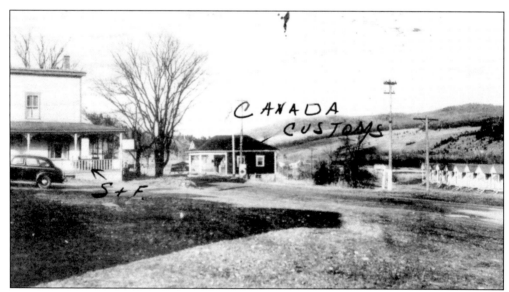

CUSTOMS, EAST HEREFORD, QUEBEC, 1940S. Stan and Flo, who sent this postcard, complained that "rain and bad roads" had delayed their progress. They overnighted at the hotel across from the customs in East Hereford. East Hereford, opposite Beecher Falls, was the scene of a great deal of drinking—and rum-running—during Prohibition. This postcard was published by Photogelatine Engraving, Ottawa, Ontario.

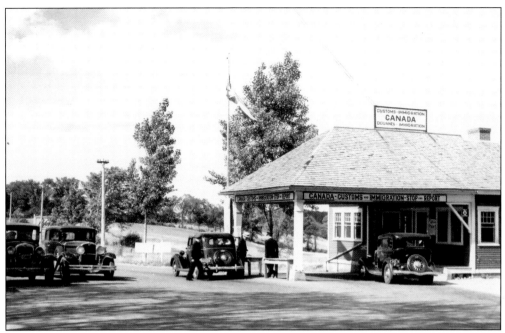

CUSTOMS AND IMMIGRATION, PHILIPSBURG, QUEBEC, C. 1930. Unlike the bunkerlike buildings that are sometimes seen today, the customshouses of the early 20th century were modest affairs. This view was taken at the Philipsburg-Highgate border. Note the bilingual signs.

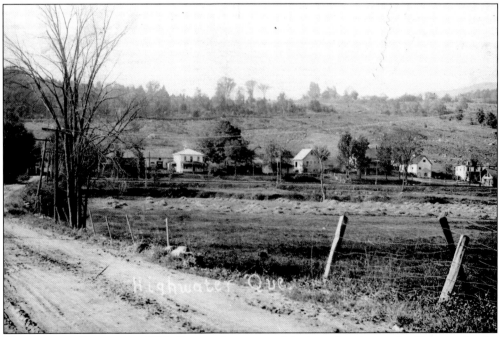

HIGHWATER, QUEBEC, C. 1920. During the winter, this sleepy hamlet on the Vermont border is the usual entry point for Americans skiing at Owl's Head Mountain, in Quebec, and for Canadians returning from Jay Peak in Vermont.

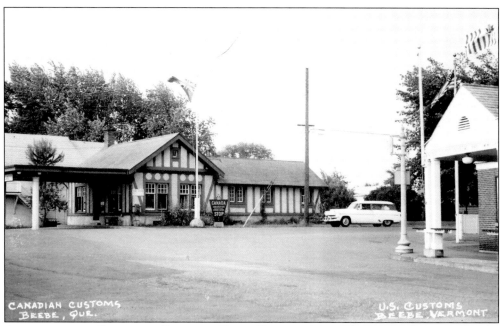

AMERICAN AND CANADIAN CUSTOMS, BEEBE PLAIN, 1950S. The customshouses in Beebe Plain, Vermont, and Beebe Plain, Quebec, face each other from opposite sides of Canusa Street. The Canadian customs was built so close to the border that the Canadian flag in this photograph was actually flapping in the United States. (Photograph by Harry Richardson.)

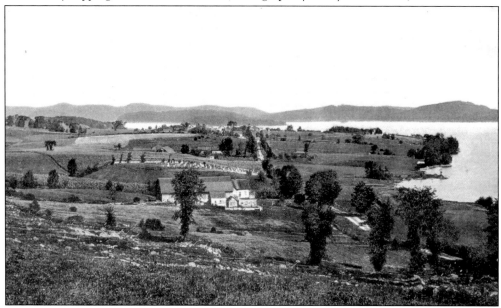

LAKE ROAD, MEMPHREMAGOG, C. 1910. Until recently, dozens of unguarded roads traversed the border. Signs instructed motorists to report directly to the nearest customs, which in some cases was miles away. Needless to say, smuggling was common and law enforcement difficult. The Lake Road between Newport, Vermont, and Leadville, Quebec, on the west side of Memphremagog, was one such road. Most of these roads are now closed. This image was published by Bigelow's Pharmacy, Newport.

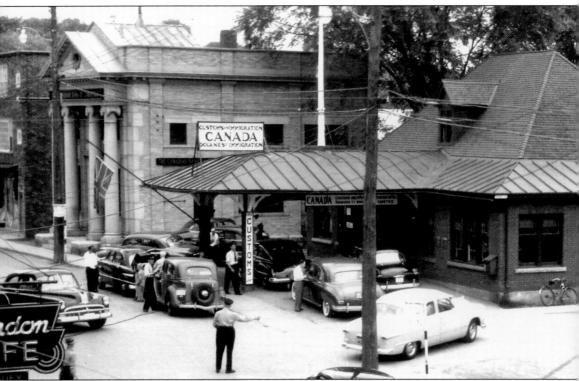

GUARDING THE BORDER, C. 1950. Three unguarded streets linked Derby Line, Vermont, to Rock Island, Quebec. After September 11, with concerns about terrorists potentially using these streets, and the growing number of illegals apprehended crossing the border, these streets became the focus of attention. Law enforcement agencies sought to close them to all vehicles, while the local communities preferred to keep them open. Closing them, they argued, would hinder the passage of fire trucks to fires on either side of the line. It would also diminish the spirit of unity that exists between the two border communities. According to retired U.S. Border Patrol agent Brian McNeal, of Newport, Vermont, who spent 15 years of his 25-year career on the Mexican border, the U.S. government wants the border to be a divider. "They will destroy what we have here," he says. "We don't see any borders. But they want us to see the border as a separator. On the Mexican border, we were shot at once a month; but never up here. For the government, though, a border is a border." (Photograph by Harry Richardson.)

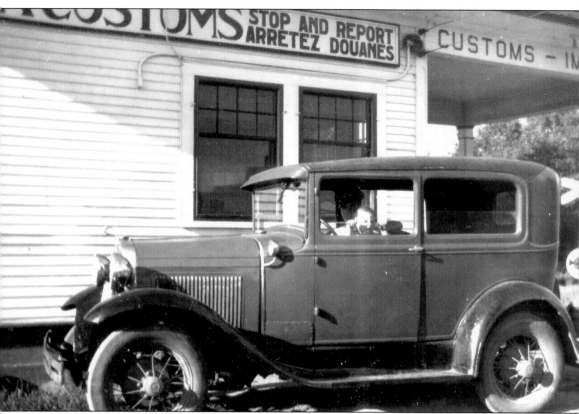

CUSTOMS, LINEBORO, QUEBEC, 1951. Opposite North Derby, Vermont, Lineboro was the point where the Quebec Central Railway crossed the border. The customs, opened in the 1930s, served trains making flag stops at Lineboro, as well as vehicular and pedestrian traffic. According to Beebe resident Ramsey Williams, a retired customs officer who worked for two years at the crossing, the construction of the customs was a "make-work program during the Depression." Williams, whose son is pictured here, remembers as a child seeing a carload of Americans crossing at Lineboro on their way to a bar in Canada. An African American man, on the fender, played guitar. The customs closed in 1937, reopened in 1949, and closed again permanently in 1953. There was no corresponding American customs, and southbound drivers had to report in Newport, Vermont. Since many were travelling only as far as cottages on Lake Memphremagog, they likely did not bother. (Ramsey Williams collection.)

NO Iron Curtain Here!

A Story of Derby Line, Vt.

"NO IRON CURTAIN HERE!" Thus read the cover of a pamphlet published by Esso in 1950, spotlighting the company's Derby Line distributor, "Turk" MacLean, and the close ties between the local border communities. According to the pamphlet, "friendliness, cooperation and goodwill bridge this border in sharp contrast to the iron curtain" found elsewhere in the world. (James Farfan collection.)

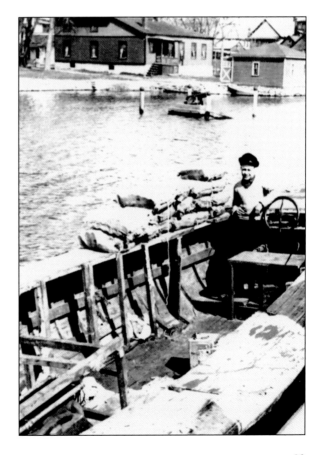

LIQUOR SEIZURE, LAKE CHAMPLAIN, C. 1930. The back roads were not the only way to smuggle into the United States. Three lakes span the Vermont-Quebec border, and over the years many attempts have been made to enter Vermont by boat. Posing here with a captured boatload of alcohol is Armand "Midget" Lavigne, of the U.S. Customs Boat Patrol on Lake Champlain. Then, as now, vehicles employed in the transport of contraband could be seized. (Scott Wheeler collection.)

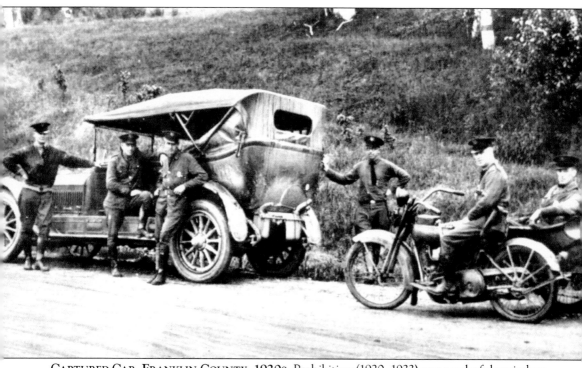

CAPTURED CAR, FRANKLIN COUNTY, 1920s. Prohibition (1920–1933) was a colorful period on the border. High-speed car chases along the back roads of northern Vermont were a common occurrence. With the manufacture and sale of alcohol banned in the United States, producers in Canada stepped in to fill the void. There was no shortage of people willing to chance transporting the contraband across the border. They were well paid, and the risks seemed acceptable in light of the limited number of lawmen and the many unwatched crossings. Indeed, rum-running could be extremely profitable and some large fortunes were made. Lawmen were sometimes successful, however, as this photograph testifies. Here federal agents pose with a captured car. Its driver surrendered after agents put four bullets into it—three of them into the gas tank. Since 1924, the United States Border Patrol has been responsible for policing the border, and for apprehending people who cross illegally. The Royal Canadian Mounted Police handle these duties in Canada. (Scott Wheeler collection.)

SKINNER'S CAVE, LAKE MEMPHREMAGOG, C. 1900. Skinner's Cave, on Skinner's Island, Lake Memphremagog, is associated with several legends. One, recounted in the *Stanstead Journal* of 1853, states that the native people believed the cave to be "the den of the demon of the lake . . . a huge serpent." Another tale contends that the cave was named after a member of Rogers' Rangers who was besieged there in 1759 by Abenakis, following the soldiers' attack on their village of Odanak. Best known of all, however, is the story of Uriah Skinner, a smuggler who reputedly used the island as a base during the War of 1812. According to this legend, Skinner would bring his goods up the lake by boat. On one occasion—his last—he was supposedly pursued to the island by revenue officers, hid in the cave, and eventually died there. All that was found of him were his bones.

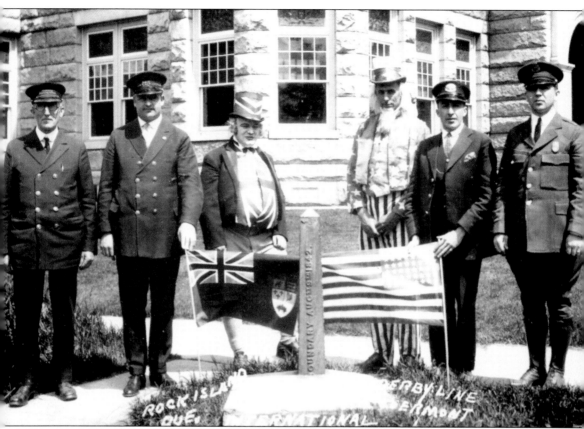

CROSS-BORDER PATRIOTISM, DERBY LINE, VERMONT/ROCK ISLAND, QUEBEC, 1920S. Perhaps nowhere along the border is the sense of cross-border community as strong as it is as at the Haskell Free Library and Opera House, North America's most famous international building. Posing for this photograph are, on the Canadian side, John Bull and two unidentified officers from Canada Customs and Canada Immigration. On the American side are (from left to right) Uncle Sam, Wayne "Woodie" Woodworth, of U.S. Customs, and his friend, Rocco Novia, of U.S. Immigration. Note the flags—the stars and stripes with 48 stars, and the red ensign, Canada's flag until 1965. The occasion for the photograph may have been one of the many Fourths of July or Dominion Days (July 1) celebrated with equal zeal in this unusual community.

Five

WORKING

In a 2007 statement on "preserving strong relations with our international neighbors," U.S. senator Patrick Leahy of Vermont said:

> We must protect our borders, but do it sensibly and intelligently. Instead, the Administration's policy threatens to fray the social fabric of countless communities that straddle the border; they have needlessly offended our neighbors, sacrificed much of the traditional good will we have enjoyed, and undermined our own economy in border states. Local chambers of commerce along the border estimate that the costs will amount to hundreds of billions of dollars.
>
> I have heard from many Vermonters about problems they have encountered at U.S. border crossings—from long traffic backups to invasive searches and questioning to inadequate communication from federal authorities about new facilities and procedures. Such a top-down approach does not work well in interwoven communities along the border, where people cross daily from one side to the other for jobs, shopping, and cultural events.
>
> Canada has been an important trading partner and friendly neighbor to Vermont and the United States for more than 200 years. It is in the best interests of both of our countries to keep those relations as positive and productive as possible.

Like other politicians representing jurisdictions at various levels along the Canada-U.S. border, Senator Leahy has been a vocal advocate of a reasonable approach to border security. This approach accepts the need for enhanced security, but also recognizes the way of life and the concerns of people living in towns and villages along the border, and the importance of cross-border trade to local economies.

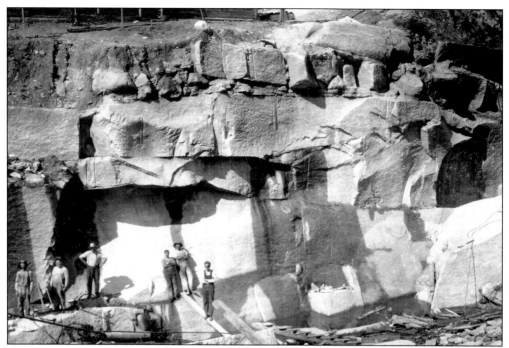

STONE WORKERS, DERBY, C. 1915. Granite has been quarried in Derby, Vermont, since at least the 1830s. Across the line, Stanstead is considered the "Granite Capital of Canada," and the largest quarry in the area is in nearby Graniteville.

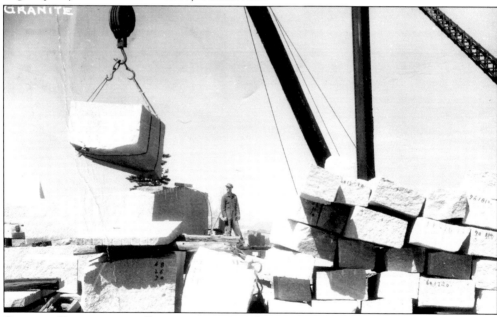

QUARRY, GRANITEVILLE, QUEBEC, C. 1950. The quarry in Graniteville, near the Vermont border, is owned by Rock of Ages, of Barre, Vermont, and Beebe, Quebec. Granite from Beebe has been used in buildings across Canada. One of them, Sun Life in Montreal, was the largest office building in the British Empire when completed in 1933. Its construction kept much of Beebe employed during the Depression.

FARMING, DERBY, 1870S. Farming was the basis of the economy for generations on both sides of the line. Some of the most splendid agricultural scenery could be found in Derby, overlooking Lake Memphremagog. This part of the Northeast Kingdom is as stunning today as it was a century and a half ago. (Photograph by D. A. Clifford.)

CLYDESIDE, DERBY, 1886. Born in Quebec's Eastern Townships, Josiah Grout moved to Vermont as a child. Governor of Vermont from 1896 to 1898, Grout's 700-acre farm, Clydeside, boasted 5,000 sugar maples, 140 cultivated acres, 425 acres of pasture, five barns, a creamery, a carriage house, and housing for employees. The Grouts, who also bred dairy cattle, horses, sheep, and pigs, lived in a mansion on the premises.

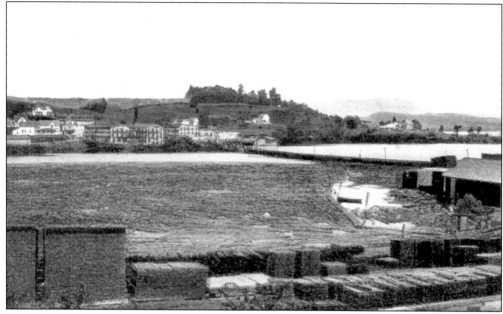

LOG BOOMS, MILLS, NEWPORT, C. 1910. Newport has been home to several mills. Softwood, hardwood, and veneer mills have all contributed to the local economy. In this view, a log boom almost fills Prouty Bay, at the southwest extremity of Lake Memphremagog. In the foreground is the Prouty and Miller sawmill and planing operation; across the bay is the Frost Veneer Seating Company. This image was published by Bigelow's Pharmacy, Newport, Vermont.

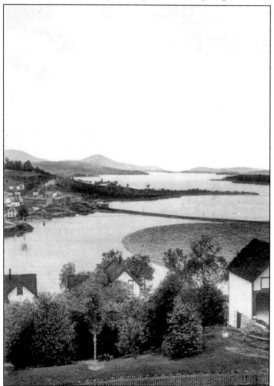

LOGGING, LAKE MEMPHREMAGOG, C. 1910. The largest lumber concern in Newport was Prouty and Miller. At its peak, the company controlled tens of thousands of acres of timberland around Memphremagog, most of it in Canada. Logs from as far away as Mount Orford, near Magog, were sent to Newport. Softwood was towed down the lake in giant booms by tug; hardwood was shipped by barge. This image was published by Bigelow's Pharmacy, Newport.

ROUND BARN, JAY, C. 1910. The rugged surroundings of Orleans County provide the backdrop to a round barn. Constructed on both sides of the border in the early 1900s, round barns are rare today. They are the subject of superstition, much of it relating to the devil. The absence of corners, it was said, eliminated places where the devil could hide, a notion associated with the Shakers, who built some of New England's earliest round barns. The motives for constructing the round barns of Vermont and Quebec, however, had more to do with economy than the devil. The shape provided efficient organization of space. Cattle were oriented toward the center, facilitating feeding and cleaning; windows provided sunlight throughout the day; and the shape minimized the impact of strong winds. There were disadvantages, however. Round barns were difficult to expand. And the shape required more, and shorter, pieces of wood for the siding. Ultimately, technological advances (such as improved piping) rendered these barns obsolete.

TONIC MAKERS, EAST FRANKLIN, VERMONT/FRELIGHSBURG, QUEBEC, 1880s. Like many businesses, Rowell and Son had addresses in Vermont and Quebec. Its "Invigorating Tonic" was said to be "unequalled as a cathartic—moving the bowels thoroughly and without pain, griping or weakness." It was also advertised as a cure for impure blood, piles, memory loss, eruptions of the skin, and disorders of the liver and kidneys. And all for only $1 a bottle!

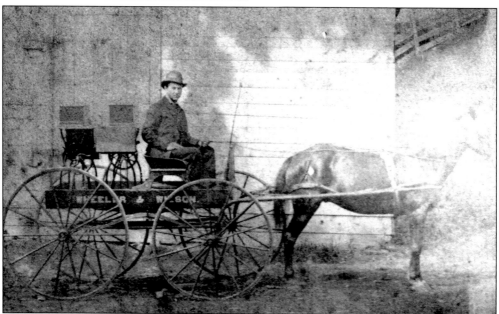

SEWING MACHINE DELIVERY, MORGAN, 1870s. In the 19th century, it was common for tradesmen to travel from town to town, peddling their wares or services. Some of them operated on both sides of the border. The man in this photograph is transporting Wheeler and Wilson sewing machines. Wheeler and Wilson was a major sewing machine manufacturer until the company was acquired by Singer in 1905. (Photograph by Farmer Taylor.)

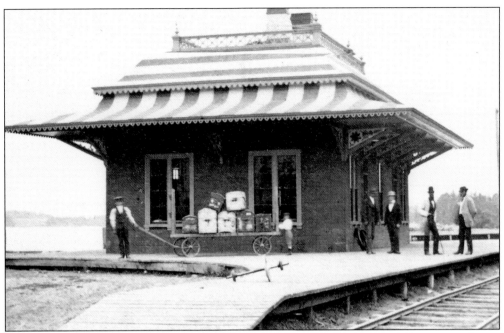

BAGGAGE HANDLER, STATION, NEWPORT, 1870S. The Connecticut and Passumpsic Rivers Railroad reached Newport, Vermont, in 1863. Until the line was extended up to Canada a few years later, passengers had to travel that leg by stagecoach. Newport's first station was built in 1869. In this view, a baggage handler poses with a cart laden with trunks while passengers await the train. (Photograph by D. A. Clifford.)

CANADIAN PACIFIC LOCOMOTIVE, NEWPORT, 1947. Newport has been served by the Connecticut and Passumpsic, the Boston and Maine, the South Eastern, and the Canadian Pacific railways. The railways brought trade, tourism, and prosperity. The mid-1960s marked the end of an era, however, when passenger rail service was discontinued.

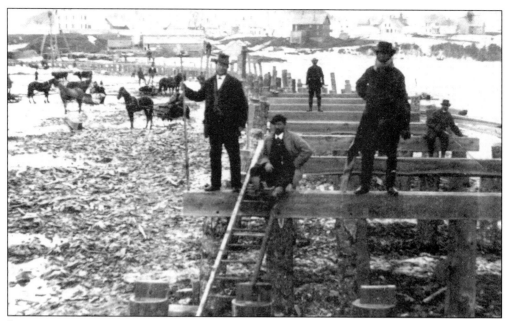

BRIDGE BUILDERS, NEWPORT, VERMONT, 1870S. These men are building a railway across a frozen Prouty Bay, on Lake Memphremagog. The South Eastern Railway ran from West Farnham, Quebec, to Newport. For part of the way, it followed the Missisquoi River, which meandered back and forth across the border. The Missisquoi and Clyde Rivers Railroad, above, was chartered for the section in Vermont. (Photograph by L. E. Thayer.)

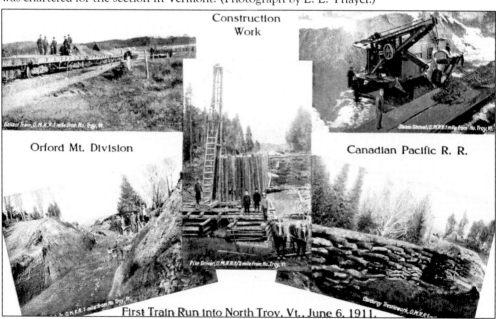

CONSTRUCTION, CANADIAN PACIFIC RAILWAY, NORTH TROY, 1910. The Orford Mountain Railway was leased by Canadian Pacific in 1910 and extended south from Mansonville, Quebec, to a point near North Troy, Vermont. This postcard depicts scenes of the construction of this five-mile (eight-kilometer) stretch, including a ballast train, steam shovel, and pile driver. The first train on the new line pulled into North Troy on June 6, 1911.

POSTMISTRESS, NORTH DERBY, VERMONT, 1940. Many communities saw their post offices disappear over the course of the 20th century. Some, housed in private homes or general stores, were deemed unjustifiable in light of declining rural populations. This image captures for posterity the last day of service at the North Derby Post Office—May 15, 1940. It is signed on the back by postmistress Winifred Kilbourne. (Photograph by Harry Richardson.)

POLICE OFFICER, ROCK ISLAND, QUEBEC, 1931. At one time, many small towns had their own police forces. In Rock Island, the police had to enforce the peace at bars like the Rock Island House. Quebec's liquor laws have long been more liberal than those in Vermont where, for example, the legal drinking age is 21, three years higher than it is in Quebec.

WOOLEN MILL, CLYDE RIVER, WEST DERBY, VERMONT, 1860S. Grist- and sawmills formed the nucleus of many pioneer communities. Woolen mills and other manufacturers would also spring up along rivers that were strong enough to power machinery. The woolen mill seen here was built by Ira Adams in 1845. It could produce 75 yards of cloth per day. (Photograph by Whitney and Paradise.)

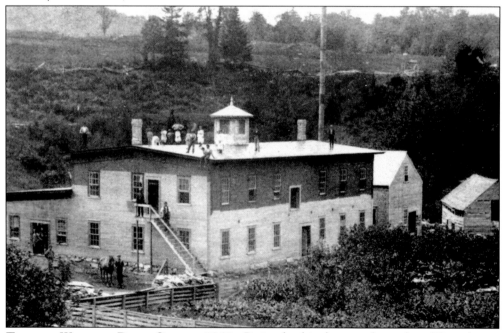

TANNERY WORKERS, DERBY CENTER, 1860S. Posing for this photograph are about 20 employees of the tannery in Derby Center, Vermont. Machinery in the tannery was powered by steam, with water supplied by the Clyde River. The tannery fell into decay in the 1880s and was torn down in 1896.

Café, Lake Wallace, 1920s. The Norton Café (D. W. Slocum, proprietor) was a roadside stop near Lake Wallace (Wallis), on the Hereford, Quebec, side of the border, opposite Canaan, Vermont. Lake Wallace, partly in Vermont, partly in Quebec, was a favorite destination for fishermen.

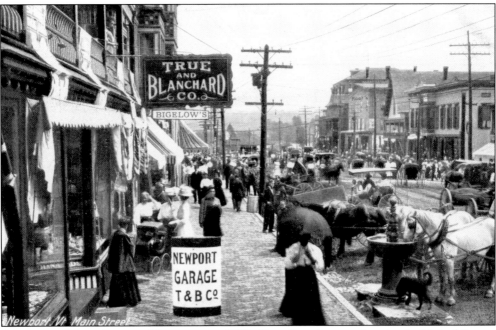

Retailers, Main Street, Newport, c. 1910. Canadians love to shop in the United States. For many, the casual smuggling of goods purchased in towns like Newport, Vermont, was once routine. Since the 1988 Free Trade Agreement eliminated duties at the border, the incentive to smuggle has been reduced. Lower retail prices and sales tax, however, still act as inducements for many cross-border shoppers. This image was published by Bigelow's Pharmacy, Newport.

SUPER MARKET, NORTH TROY, VERMONT, 1950S. Some consumers declare their purchases when they return to Canada, paying the sales tax at the customs. Others choose to smuggle. The specials in the window of this supermarket include "Toilet tissue, 6 rolls, 39 cents." Today, many small-town corner stores have closed. "Big box" stores have made survival difficult for many retailers. (Photograph by Harry Richardson.)

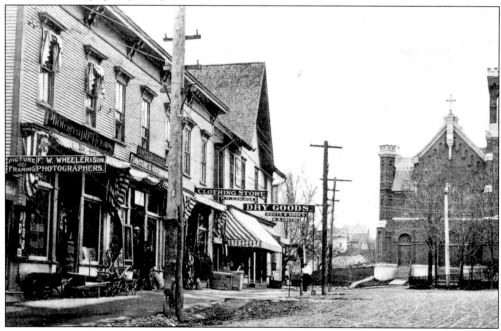

PHOTOGRAPHERS' SHOP, RICHFORD, C. 1908. F. W. Wheeler and Son, whose "photograph rooms" may be seen here on the left, was based in Richford but active in the Eastern Townships, as well—as were other photographers working in the area. This image was published by F. W. Mitchell.

Six

THE GREAT OUTDOORS

Editor, justice of the peace, and town librarian Heather McKeown of Berkshire, Vermont, was born and raised in Canada, but has lived for many years in Vermont. A dual citizen, she spoke to the author in 2008:

> The best part about living in rural Vermont is that there are no limitations to one's progress. Emotional, physical, spiritual, professional and creative ambitions are not stifled by the low expectations of a suburban status quo. . . . The voids in rural Vermont, those vacuums and black holes created by a dearth of population, beg to be filled with the concrete results of creative, hard-working, insightful folks who have escaped urban society and its roadblocks and lack of imagination.
>
> There isn't a rush to get out of the house every morning to battle a preordained rush hour commuter's blitz. . . . When a person leaves Vermont, leaves his relatives and leaves the leaves, Vermont will never abandon him. This state is a state of mind.

Canadians have always felt at ease in Vermont, and vise versa. This is probably as true today as it was in the early 1800s, when hundreds of families migrated from Vermont to the Eastern Townships, or, later, when French Canadians moved to Vermont in droves. These bonds are strengthened by the fact that many people living on both sides are citizens of both countries.

MARSHALL'S CAMP, LAKE WALLACE, C. 1930. Lake Wallace (or Wallis), in Canaan, Vermont, is traversed by the border. About two thirds of the lake is in Quebec. Marshall's Camp was a magnet for visitors attracted by the excellent trout fishing. Today a fishing license issued by either Vermont or Quebec permits boaters to fish anywhere on the lake. (Photograph by the Eastern Illustrating Company, Belfast, Maine.)

LAKE CARMI, FRANKLIN, 1940S. The fourth-largest natural lake entirely in Vermont, Lake Carmi is the source of the Pike River, which flows north into Quebec. The lake is home to cottages and a state park and is popular with fishermen and campers.

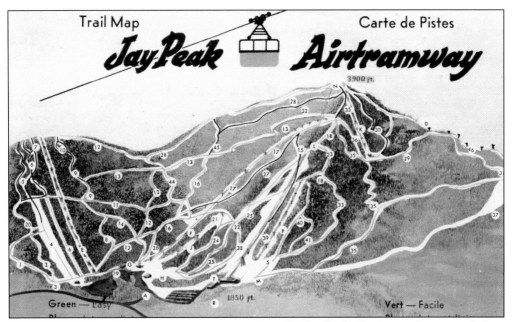

TRAILS, JAY PEAK, C. 1970. Since opening in 1957, Jay Peak Ski Resort has upgraded its facilities several times. Home to "Vermont's only aerial tram" since 1966, Jay reaches an altitude of 3,858 feet (1,176 meters) and boasts the greatest average annual snowfall (355 inches or 9.2 meters) of any resort in eastern North America. Located just south of the Canadian border, Jay caters to an international clientele.

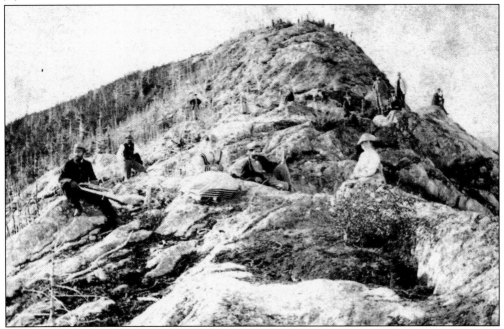

SUMMIT, JAY PEAK, 1870s. Long before there were ski trails and trams, and before the mountain was one of Vermont's premier attractions, Jay Peak was a magnet for outdoor enthusiasts. In this early view, a group of 15 well-dressed hikers, men and women, poses at the summit. The man at left appears to be holding a trumpet. (Photograph by L. E. Thayer.)

SPRING THAW, MISSISQUOI BAY, LAKE CHAMPLAIN, C. 1910. Lake Champlain is roughly 125 miles (200 kilometers) long. Most of the lake is in the United States with the Vermont/New York state line extending up the middle. Missisquoi Bay, at the northeast tip, straddles the Canada-U.S. border.

MISSISQUOI PARK, HIGHGATE SPRINGS, C. 1900. Missisquoi Bay has been a summer destination since the 19th century. Highgate Springs owed its start to the supposed therapeutic benefits of its mineral springs and to its picturesque location on Lake Champlain. This image was published by Leighton and Valentine, New York.

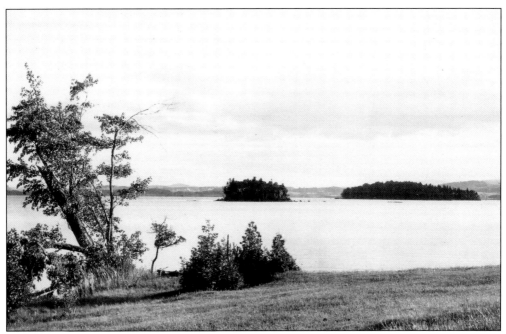

EAGLE POINT, LAKE MEMPHREMAGOG, 1930S. One of the jewels of the Northeast Kingdom, Memphremagog is known for its islands, points, and coves. Eagle Point, seen here, lies just south of the international boundary. Not far away are Cove, Bell, and Black Islands, with Newport, Vermont, in the distance. (Photograph by Harry Richardson.)

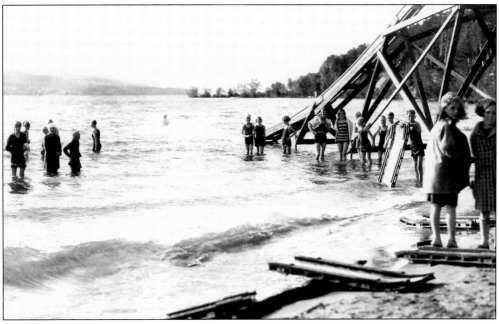

WATER SLIDE, NEWPORT, C. 1930. Camp Elizabeth, on Indian Point in Newport, was a bustling spot in the summer. Among the camp's attractions were its view of Memphremagog, its beach, and—always a favorite with the children—its water slide. (Photograph by Arrowhead Art Shop.)

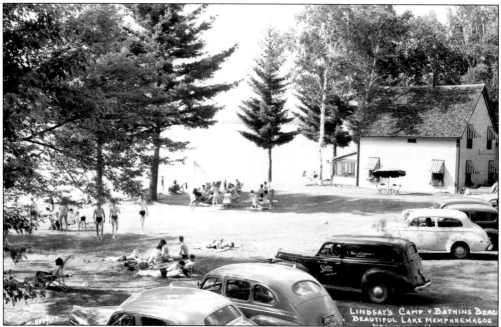

LINDSAY BEACH, NEWPORT, VERMONT, 1940S. During the summer months, Lindsay's Camp and Bathing Beach, on Lake Memphremagog, was popular with vacationers. For 25¢, locals from both sides of the border could swim at the beach. Home-cooked meals were also available. (Photograph by Harry Richardson.)

MAXFIELD LIGHTHOUSE, LAKE MEMPHREMAGOG, C. 1915. Soon after steamers began operating on Memphremagog, lighthouses were installed on strategic points and islands up and down the lake. At one time there were nine of these navigational aids between Newport and Magog, Quebec, at the north end of the lake. Maxfield Light, seen here, was midway between Newport and the border.

NEWPORT FISHERWOMAN, C. 1910. The region has produced some colorful characters. Maggie Little was a beer-swigging, pipe-smoking eccentric who spent her time fishing from the bridge in Newport and who lived to be 91. A contemporary brochure reported that Maggie was "known the world over for her pleasant smile, wielding of the axe, sawing of wood, and the greatest of accomplishments in her line—catching of the wily perch." (Photograph by Harry Richardson.)

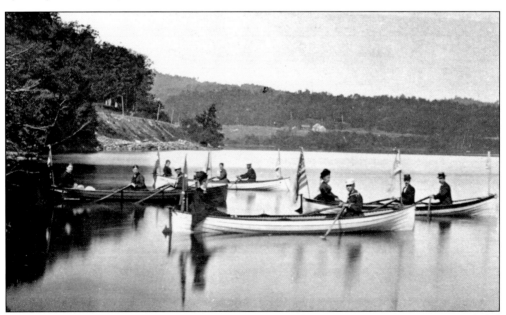

BOATING, LAKE MEMPHREMAGOG, 1880S. The Memphremagog House's amenities included "good boats of a light, graceful pattern." And, as this hotel advertising card attested, "the many beautiful rivers which flow into the lake, the abundance of pond lilies, [and] the fishing and wild duck shooting" made for excellent boating activities. (Photograph by D. A. Clifford.)

BLACK ARROW CANOE CLUB, MEMPHREMAGOG, C. 1908. By the early 1900s, canoeing was a craze across North America. Cedar canoes, like those seen here, could be used for racing, fishing, or recreation and were more lightweight than traditional rowboats. They also had a certain romantic appeal, being, after all, the mode of transport of the native peoples who paddled these waters for centuries before the arrival of the settlers. This image was published by Bigelow's Pharmacy, Newport, Vermont.

REGATTA, MEMPHREMAGOG YACHT CLUB, NEWPORT, 1913. The Memphremagog Yacht Club was founded for owners of steamboats and other pleasure craft. The club had over 200 members from the American and the Canadian sides of the lake. Each year, regattas, picnics, and swimming races were held for members. (Photograph by E. L. Chapin.)

CLYDE RIVER, WEST DERBY, VERMONT, 1860S. Over the years, the Clyde has been dammed in several places, taking a toll on its once plentiful landlocked salmon population. Publisher Scott Wheeler, who grew up here in the 1970s, says that "we didn't have to look further than the Clyde River to keep us occupied," whether it was "fishing, swimming, hunting for crawfish, or shooting the rapids in inflated tractor tires." (Photograph by D. A. Clifford.)

LAKE WILLOUGHBY, 1869. Willoughby occupies a glacial trough between Mounts Hor (2,651 feet; 808 meters) and Pisgah (2,752 feet; 839 meters). It reaches a depth of 312 feet (95 meters), making it not only very deep but very cold. This view of an intrepid hiker in overcoat and top hat was taken from Mount Pisgah. To this day, Willoughby is famous for its hiking trails. (Photograph by J. L. Lovell.)

ALONG THE CENTRAL VERMONT RAILWAY, MISSISQUOI VALLEY, C. 1900. Chartered in 1867, the Missisquoi Railroad was leased and eventually purchased by the Central Vermont Railway. The line ran from St. Albans to Richford, following the Missisquoi River (above) for much of its way.

DUFFERIN HEIGHTS, QUEBEC, C. 1930. Founded in 1922, Dufferin is one of the prettiest golf courses in the Eastern Townships. At 1,500 feet (457 meters), it has a splendid view of the border region for miles around. The course is popular among Canadians and Americans.

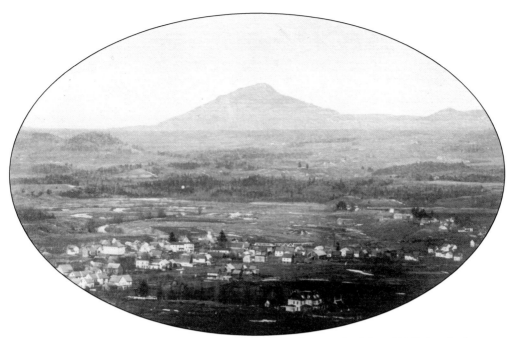

NORTH TROY AND OWL'S HEAD MOUNTAIN, C. 1905. During the War of 1812, local selectmen were authorized to purchase muskets and bayonets to defend Troy from an invasion from Canada. The invasion never came. This view depicts North Troy, looking north into Potton, Quebec. Owl's Head, like other peaks in the vicinity, is a Canadian extension of the Green Mountains.

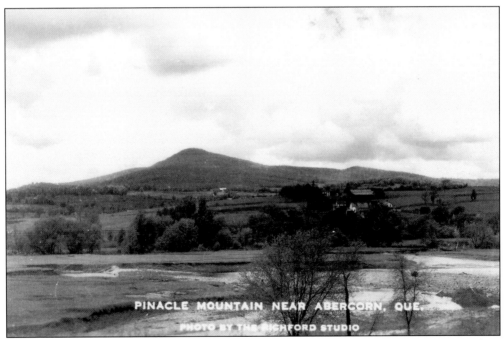

PINNACLE MOUNTAIN, C. 1930. The Pinnacle is as much a backdrop for Abercorn, Quebec, seen here, as it is for Richford, Vermont, immediately to the south. In this view, the Sutton River winds its way south toward the U.S. border.

Cold Spring Camp, Lookout on Big Averill Lake

Wigwam on shore, Forest Lake.

Road leading to Cold Spring Camp.

Boat Landing at "Wigwam".

A Corner of Forest Lake, Cold Spring Camp in distance

A Corner of Big Averill Lake.

AVERILL, C. 1908. Cold Spring Camp, in Essex County, was a trout fishing destination at the dawn of the 20th century. Visitors to this remote camp could try their luck on Forest Lake, Big Averill Lake, or Little Averill Lake. The town of Averill is sandwiched between Canaan and Norton, on the Canadian border. This image was published by C. M. Quimby, Averill, Vermont.

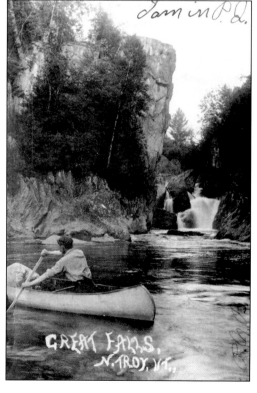

FALLS, NORTH TROY, VERMONT, 1905. Big Falls (or Great Falls) on the Missisquoi River, is a local landmark. The falls, which tumble through an impressive rock canyon, have been depicted on postcards like this one for over a century. Epitomizing the romanticized view of the wilderness that was so typical of the Victorians is the solitary canoeist posed against the pristine natural backdrop.

Seven

Hotels and Watering Holes

In an 1879 brochure, Charles Gleason, manager of the Memphremagog House in Newport, Vermont, boasted of the benefits of his hotel:

> The location of the House is such as to afford a cool and delightful breeze off the water. . . . The atmosphere is of an exceptional purity, and is particularly favorable for the restoration to health of persons afflicted with pulmonary complaints, malarial disorders and hay fever. The drives are delightful and exceedingly varied; over good roads, along the Lake on either side, by the sides of rivers, and on hill tops, from which rare and grand views may be had of the highest mountains in Vermont and Canada.

Hotels all along the border catered to travelers heading in and out of Canada. In the 19th century, some served as stagecoach stops. Customers could have a meal or stay the night. Others were tourist attractions in and of themselves, boasting proudly of their amenities. Still others depended on the local surroundings and entertainments to entice their customers. By the early 20th century, the proliferation of the automobile and the construction of modern highways, some of which bypassed small communities altogether, began to take their toll on local hotels. Many closed down for lack of patronage or were converted into bars.

In recent years, tourism has become a force again in the local economy on both sides of the border. As always, people are lured by the area's natural attractions. Some are deterred from crossing the border because they are intimidated by the inspections. For others, the border poses more of a psychological barrier, which they hesitate to cross. For others still, it is an attraction, a curiosity. Indeed, is not uncommon to see tourists having themselves photographed at the line.

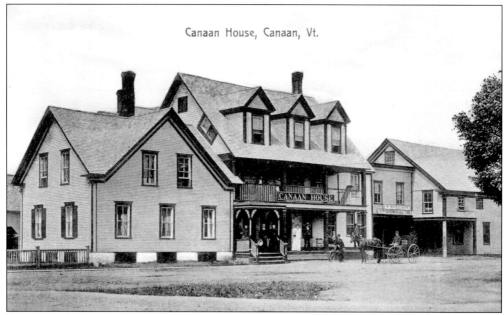

Canaan House, Canaan, Vt.

CANAAN HOUSE, CANAAN, VERMONT, C. 1908. Canaan is a stone's throw from Quebec and New Hampshire. Residents from both sides of the line come here to shop, to visit family, and to socialize. Residents Bill and Irene Owen, of Hereford Hill, Quebec, cross the border every Saturday for a night on the town. The draw is dinner and dancing at the local hotel. This image was published by Johnson and Green, Canaan, Vermont.

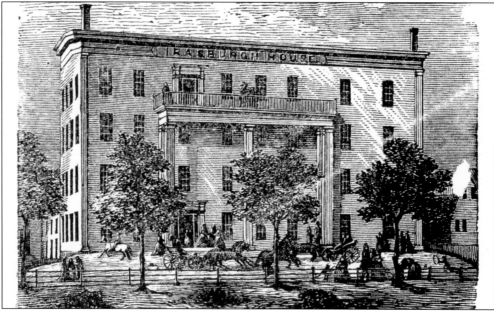

IRASBURGH HOUSE, IRASBURG, VERMONT, 1870S. Irasburg (or Irasburgh, as it was sometimes spelled) was at one time the Orleans County seat. Prosperous businesses surrounded the village common, including the elegant four-story hotel depicted here. Irasburgh House, as it was called, offered "conveyance to and from mail trains at Barton Landing." The hotel was the property of Burton Pike.

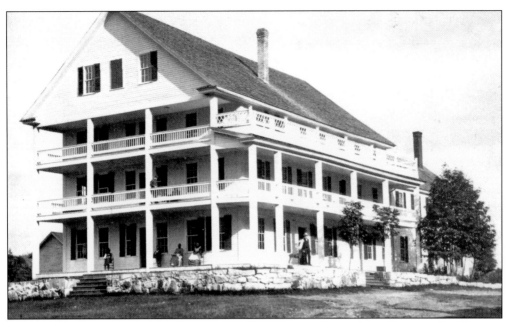

WILLOUGHBY LAKE HOUSE, WESTMORE, VERMONT, 1870s. According to the *Vermont Historical Gazetteer* (1878), the scenery here was "excitingly picturesque and romantic." In the summer, the climate was "very salubrious and many people resort here for health, pleasure and recreation." The hotel, which burned in 1904, was renowned for its annual Fourth of July Ball, which attracted revelers from around Orleans County. (Photograph by Farmer Taylor.)

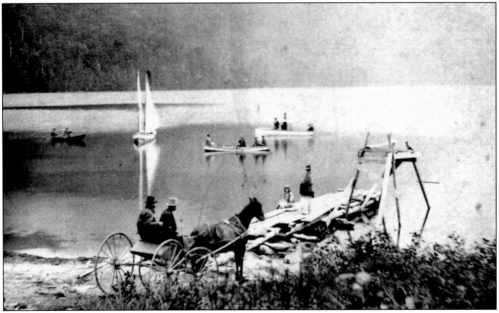

BOATING, LAKE WILLOUGHBY, 1870s. In the 19th century (as today), Willoughby was one of the most photographed lakes in Vermont. Built in 1852 by Alonzo Bemis of Lyndon, Lake Willoughby House prided itself on its rustic surroundings. Guests were lured by the mountain setting and the cool, clear waters. Fishing, hiking, and boating were other attractions. (Photograph by Farmer Taylor.)

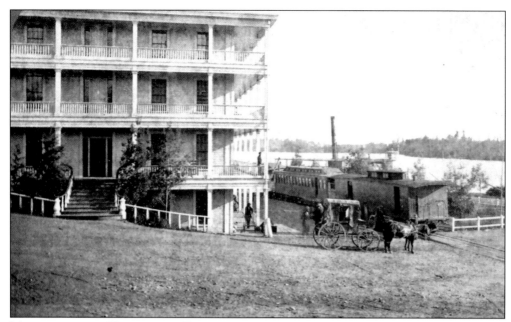

MEMPHREMAGOG HOUSE AND TRAIN, NEWPORT, C. 1870. Erected in the mid-1800s and enlarged several times, at its peak, Memphremagog House could accommodate over 400 guests, making it one of the largest hotels in Vermont. The steamers docked at the waterfront and the terminal of the Connecticut and Passumpsic Rivers Railroad (which owned the hotel for a time) was nearby. (Photograph by H. T. Blanchard.)

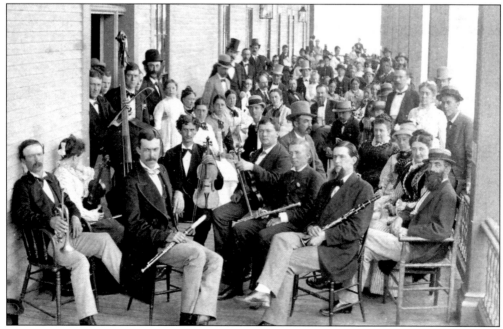

BAND, MEMPHREMAGOG HOUSE, 1870s. This photograph of guests posing with the hotel band on the building's massive wraparound balcony gives an idea of the size of the establishment. Like many hotels of that era, the Memphremagog House was built entirely of wood. It burned to the ground in 1907. (Photograph by D. A. Clifford.)

"HOTEL," JAY PEAK, 1871. Visible in the distance, Jay Peak was still wilderness when this photograph was taken. The rustic nature of the accommodations, the primitive surroundings, and the rutted track suggest a genuine frontier. (Photograph by L. E. Thayer.)

LINE HOUSE, CANAAN, VERMONT/HEREFORD, QUEBEC, 1920S. Built astride the Canada-U.S. border, the Canaan Line House was a watering hole during Prohibition. The law across the United States between 1920 and 1933, Prohibition outlawed the manufacture, sale, and transportation of alcohol. Alcohol purchased on the Canadian side of an international tavern had to be consumed on the premises. Line houses and bars north of the border boomed in this period.

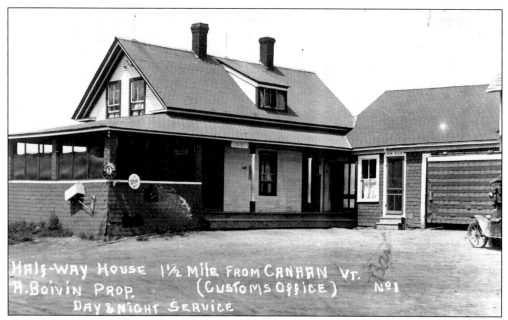

HALF-WAY HOUSE, HEREFORD, QUEBEC, 1924. There were several roadside bars in the Hereford area. Some of them were rough and tumble shacks hastily converted for this purpose during Prohibition. The Half-Way House, a half mile from Canaan, Vermont, offered "day and night service." Beer was 10¢ a glass.

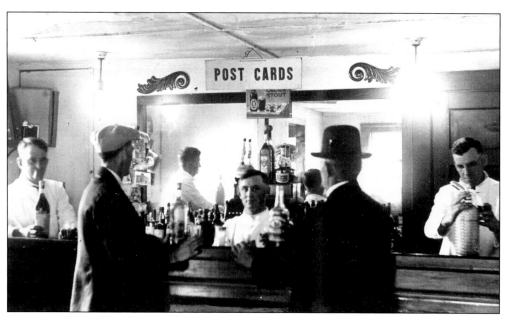

BARROOM, HALF-WAY HOUSE, HEREFORD, QUEBEC, C. 1924. The cramped, fly-by-night nature of this bar is apparent by the low, water-stained ceiling, the naked lightbulbs, and the blurred people in the foreground (suggesting the photographer had little room to maneuver).

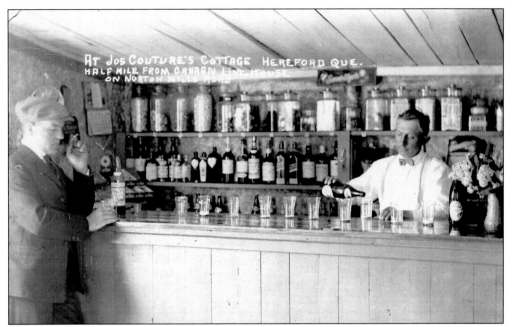

JOS COUTURE'S COTTAGE, HEREFORD, QUEBEC, 1920S. This establishment was a half mile from the landmark Canaan Line House on the Norton Mills Road. Note the shelves: beer on the bottom, hard liquor in the middle, sweets on top.

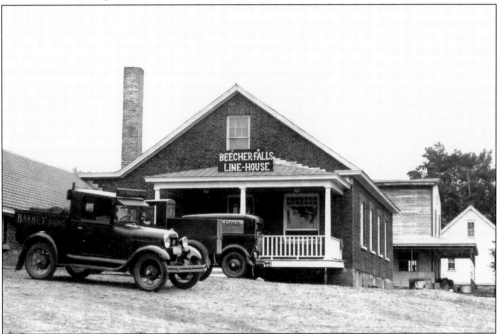

LINE HOUSE, BEECHER FALLS, VERMONT/EAST HEREFORD, QUEBEC, 1920S. In Canada, liquor laws varied from province to province. Prohibition was attempted in Quebec for a short time (1918–1919) but was unpopular, and the issue was returned to local municipalities for decision. Some towns stayed dry, others went wet. The term *local option* referred to the ability of local municipalities to choose what course they would take.

LOCAL OPTIONISTS IN VERMONT 1033

LOCAL OPTIONISTS, VERMONT, C. 1908. Vices come in a variety of forms. This early comical postcard poked fun at the expression "local option." Of the five grinning old men, two are enjoying pipes, one a cigar, one spirits, and one a tankard of ale.

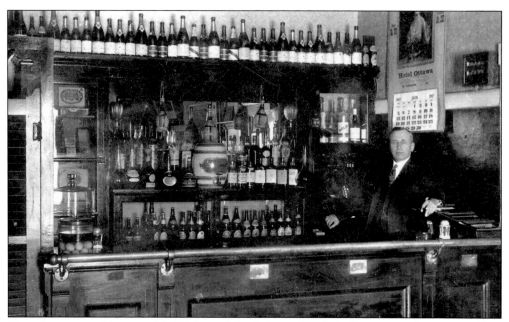

BAR, ABERCORN, QUEBEC, 1927. Many of the Prince of Wales's clients were Americans. They came by car, by train, by taxi, and by foot. Mostly they came to drink. Other bars in Abercorn were the Prince Albert; International House; Abercorn House; and the colorfully named Bucket of Blood, a shack situated feet from the customs. For the really adventurous, there was Queen Lil's, a bar and brothel in nearby East Richford.

Eight

WHEN DISASTER STRIKES

In 1976, Canadian prime minister Pierre Elliott Trudeau described the Canada-U.S. relationship in the following terms:

> Over hundreds of years we have worked and played together, laughed and mourned together, fought side by side against common enemies. Our two peoples have helped each other repair the havoc of natural disasters, inspired and applauded each other, opened our hearts and our homes to each other as to valued and welcome friends.

These words prefaced *Between Friends/Entre Amis*, a commemorative pictorial book celebrating contemporary life along the Canada-U.S. border and produced by the National Film Board of Canada in honor of the bicentennial of American Independence.

As it does with individuals, friendship between peoples and nations transcends petty differences. The U.S. and Canada have been allies and partners for generations. The significance of this bond is even more apparent in communities on the border. The things that divide Americans and Canadians usually pale in comparison to the things that bring them together. This seems particularly true in times of disaster, whether it be disaster on a massive scale, such as the September 11 attacks, when locals placed flowers and wreaths at monuments along the border, or on a more modest one, such as when fire departments from one side of the border come to fight fires on the other.

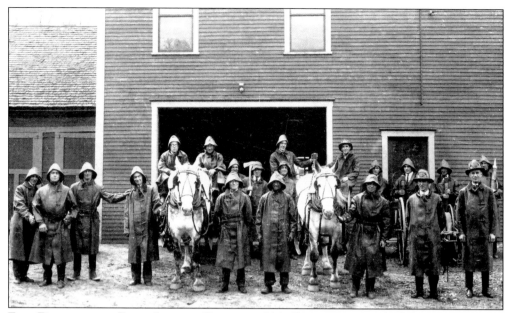

FIRE DEPARTMENT, ROCK ISLAND, QUEBEC, 1928. For generations, firefighters on opposite sides of the border have answered calls for help from towns across the line. Some of the biggest fires have been battled by crews from both countries. At one time, local towns formed an International Firemen's Association. In recent years, mutual aid agreements have been adopted, whereby participating departments come to each other's aid when called upon.

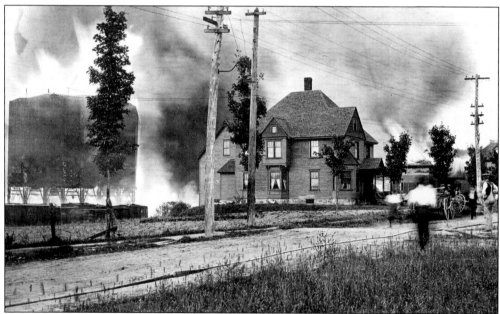

CANADIAN PACIFIC GRAIN ELEVATOR FIRE, RICHFORD, VERMONT, 1908. Natural and man-made catastrophes have long been a favorite subject for photographers and journalists. Floods, fires, earthquakes, wrecks, and explosions are sensational occurrences that seem to appeal to the morbid fascination with suffering and the destruction of life and property. In the Richford elevator fire, 17 people lost their lives and property damage was estimated at $600,000.

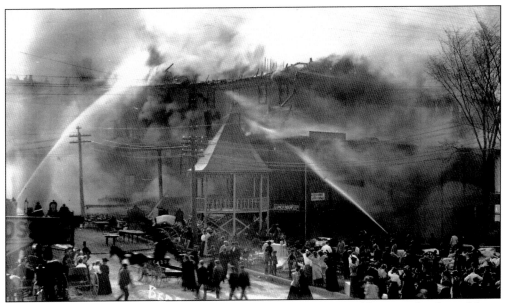

FIRE, MEMPHREMAGOG HOUSE, NEWPORT, VERMONT, 1907. Buildings made of wood have always been vulnerable to fire. This was especially true of hotels, which were designed to accommodate large numbers of people at any one time. Common causes of fire were kitchen accidents, dirty chimneys, and carelessness on the part of smokers. Fire departments did their best, but rudimentary firefighting equipment and poor water pressure often limited what could be done. (Photograph by Bedard Photo.)

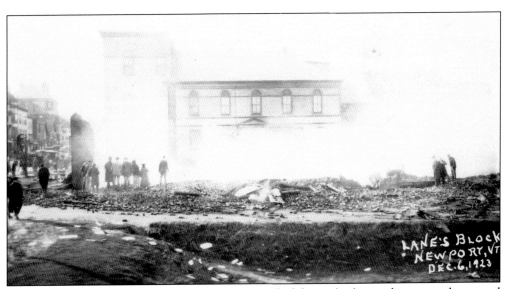

FIRE, LANE'S BLOCK, NEWPORT, 1923. The Lane Block housed a dry goods store on the ground floor. On the third floor, an opera house could accommodate 800 spectators. The building succumbed to flames in 1923.

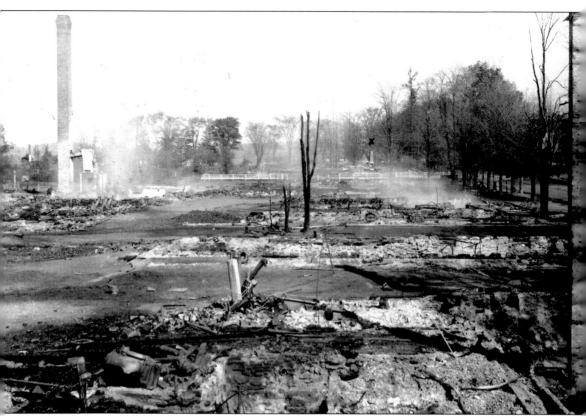

FIRE, STANSTEAD PLAIN, QUEBEC, 1915. One of the worst fires on the border was Stanstead's great fire of 1915. On the night of October 12, 1915, the village bakery caught fire. Fire crews arrived, but poor water pressure, strong winds, and dry conditions hampered their efforts. It was also reported that the big steam whistle in Rock Island, which could normally be heard for miles, could not be blown as soon as the alarm was raised because of a lack of steam. The fire spread quickly, engulfing the village's north end. By morning, about 70 buildings had been destroyed, including the town hall, a church, a hotel, and dozens of homes and businesses. The sender of this postcard commented, two weeks after the fire, "You can see how clean everything was burned up. It certainly is a sorry looking sight." Several fire departments from Vermont helped out at this fire, including those from Newport and Derby Line.

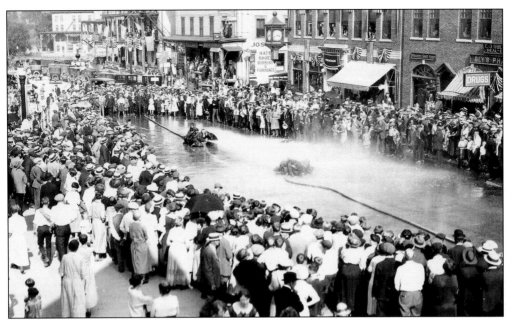

FIREMEN'S GAMES, NEWPORT, 1920s. Firemen's games—in this case, crews hosing each other down—are an excellent way for fire brigades to demonstrate skill, endurance, and team spirit. And despite the drenching these games can entail, they usually attract a crowd. In border towns, it is not uncommon for firefighters to cross the line to compete in these friendly competitions. (Photograph by Arrowhead Art Shop.)

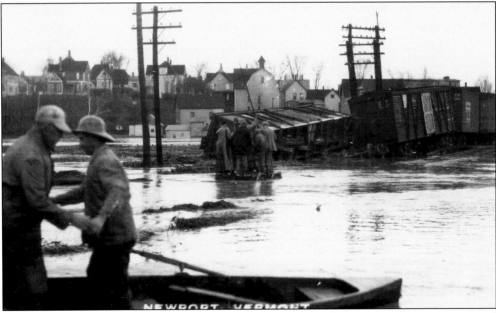

FLOOD, NEWPORT, 1927. Like all natural disasters, floods do not recognize international boundaries. The worst flooding recorded in Vermont and the Eastern Townships occurred when two storm systems collided in 1927. Torrential rains between November 2 and 4 caused flash-flooding of villages and farms across the region. In this photograph, crews assess damage to railway tracks and rolling stock in Newport. (Photograph by Arrowhead Art Shop.)

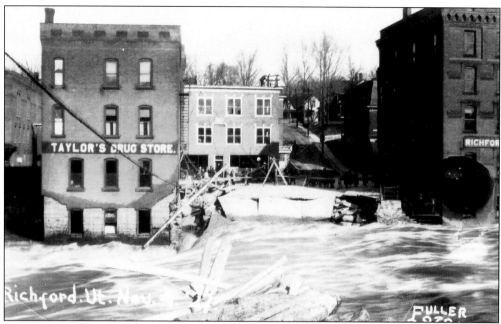

FLOOD, MISSISQUOI RIVER, RICHFORD, VERMONT, 1927. Floodwaters on the Missisquoi caused extensive damage as they raged through downtown Richford. Up to 10 inches (25 centimeters) of rain fell across the region in just a few hours. Homes, businesses, roads, bridges, and dreams were swept away. (Photograph by Fuller.)

FLOOD, TOMIFOBIA RIVER, DERBY LINE, 1927. Butterfield's, a tool plant straddling the Canada-U.S. border in Derby Line, Vermont, and Rock Island, Quebec, was badly inundated in November 1927. This view shows the torrent as it sweeps over the bridge linking the two halves of the plant.

RUNAWAY POND, GLOVER, 1860S. One of the strangest disasters in Vermont history was the sudden emptying of Long Pond, later renamed Runaway Pond, in 1810. The event occurred when residents opened a channel at one end of the pond to supply water to nearby mills. Instead of following the channel, the water sank into the earth, which proved to be like quicksand. According to text on the back of this photograph, the flow increased until "the whole body of water rushed with great force towards the valley below, cutting a channel 40 rods wide and 60 feet deep, sweeping away rocks, trees and mills, in its course to Lake Memphremagog." It took just over an hour for the pond to empty, with mud flowing for some time afterward. Fortunately, the path of the flood, the Barton Valley, was sparsely populated at the time, so no loss of life resulted. Lake Memphremagog's level, however, reportedly rose a foot (0.3 meters). When this view was taken, all that remained of the pond was dry ground. (Photograph by A. F. Styles.)

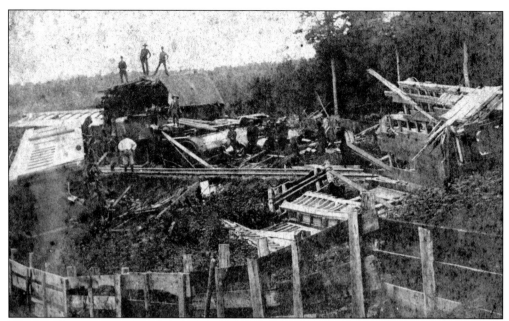

WRECK, SOUTH EASTERN RAILWAY, NORTH TROY, VERMONT, 1883. Train wrecks were spectacular events that occasionally shattered the tranquility of the countryside. Twisted metal, crews clearing away debris, and a great deal of noise were the result. Sometimes people were injured; sometimes there was death. Always there were curious onlookers (and usually at least one photographer), mesmerized by the destruction and chaos. (Photograph by H. H. Lewis.)

SNOWSTORM, NEWPORT, 1934. Vermont and Quebec have been hit by some paralyzing snowstorms. Removing the snow can be a problem. Before the age of the car, many towns were equipped with snow rollers to compact the snow so that sleighs could travel over it. With the automobile, however, it became necessary to plow and, when snow banks became too high, to cart away vast amounts of snow.

BIBLIOGRAPHY

Bullock, William B. *Beautiful Waters*, Vols. 1 and 2. Newport, Vermont: Memphremagog Press, 1926 and 1938.

Farfan, Matthew. *The Making of the Haskell Free Library and Opera House: the Construction Years, 1901–1904*. Stanstead, Quebec: Haskell Free Library, 1999.

Hay, Cecile B, and Mildred B. Hay. *History of Derby*. Littleton, New Hampshire: Courier Printing Company, 1967.

Holland Historical Society. *Holland and Its Neighbors*. Charleston, South Carolina: Arcadia Publishing, 2004.

International Boundary Commission. *Canada and the United States Annual Joint Report*, 1983.

———. *Joint Report Upon the Survey and Demarcation of the Boundary Between the United States and Canada*. Washington, D.C.: Government Printing Office, 1925.

———. *The International Boundary: A Visible Line Between Friendly Neighbours*.

McIntosh, Dave. "Customs in Stanstead County." *Stanstead Historical Society Journal*. Vol. 11, 1985, 52–67.

Moore, Arthur Henry. *History of Golden Rule Lodge, 1803-1903*. Toronto, Ontario: William Briggs, 1905.

Nelson, Emily M. *Frontier Crossroads*, Vols. 1 and 2. Canaan, New Hampshire: Phoenix Publishing, 1977 and 1978.

Sobol, John. "Life along the Line." *Canadian Geographic*. January/February 1992, 46–56.

Swift, Esther Munroe. *Vermont Place Names: Footprints of History*. Rockport, Maine: Picton Press, 2005.

Wheeler, Scott. *Rumrunners and Revenuers: Prohibition in Vermont*. Shelburne, Vermont: The New England Press, 2002.

Salisbury, Jack C. *Richford, Vermont, Frontier Town*. Canaan, New Hampshire: Phoenix Publishing, 1987.

Discover Thousands of Local History Books Featuring Millions of Vintage Images

Arcadia Publishing, the leading local history publisher in the United States, is committed to making history accessible and meaningful through publishing books that celebrate and preserve the heritage of America's people and places.

Find more books like this at
www.arcadiapublishing.com

Search for your hometown history, your old stomping grounds, and even your favorite sports team.

Consistent with our mission to preserve history on a local level, this book was printed in South Carolina on American-made paper and manufactured entirely in the United States. Products carrying the accredited Forest Stewardship Council (FSC) label are printed on 100 percent FSC-certified paper.

MADE IN THE USA